IMAGES
of America

MILLS OF
HUMBOLDT COUNTY
1910–1945

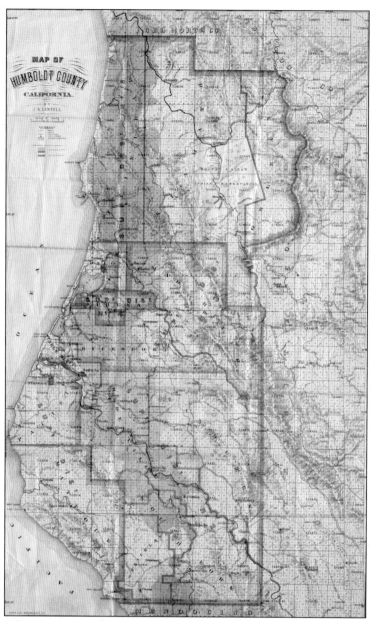

The US Forest Service estimated in 1919 that when Humboldt County's first redwood mill opened in 1853, the redwood zone from Monterey to Del Norte County was 1,406,393 acres. In 1922, the Save the Redwoods League reported, "The remaining . . . virgin redwood timber is . . . 951,000 acres . . . this area is being cut over at the rate of 6,500 acres per year." This 1914 Humboldt County map highlights the region's redwood belt. (Friends of the Redwood Libraries.)

ON THE COVER: The Pacific Lumber Company (TPL Co.) became the largest of Humboldt County's redwood lumber companies in the 20th century. Here, a TPL Co. "pond monkey" pushes logs towards the log haul. Millponds had been used for mill operations in Humboldt County since the 1850s. By the mid-1950s, millponds became obsolete, logs being stacked instead in log-decks. (Fortuna Depot Museum.)

IMAGES
of America

MILLS OF HUMBOLDT COUNTY 1910–1945

Fortuna Depot Museum
Susan J.P. O'Hara and Alex Service

ARCADIA
PUBLISHING

Published by Arcadia Publishing
Charleston, South Carolina

Printed in the United States of America

Library of Congress Control Number: 2017944525

For all general information, please contact Arcadia Publishing:
Telephone 843-853-2070
Fax 843-853-0044
E-mail sales@arcadiapublishing.com
For customer service and orders:
Toll-Free 1-888-313-2665

Visit us on the Internet at www.arcadiapublishing.com

The authors dedicate this book to Alex's children Virginia and Robert and to the students of Rio Dell and Casterlin Elementary who Susan has taught to read and to enjoy history.

CONTENTS

Acknowledgments

The authors thank the Fortuna City Council and Fortuna Historical Commission for supporting the Fortuna Depot Museum. They also thank those who have donated images to the Fortuna Depot Museum (FDM), as well as the Clarke Historical Museum (Clarke), Humboldt County Historical Society (HCHS), Humboldt State University (HSU), Humboldt Redwoods Interpretive Association (HRIA), University of California, Berkeley Marian Koshland Bioscience & Natural Resources Library, and Fritz-Metcalf photograph collection (UCB), and Phil Dwight, Dave Smeds, and the family of Emanuel Fritz for use of their images. The authors express their appreciation of the work of Lynwood Carranco and H. Brett Melendy. Melendy's master's thesis, *One Hundred Years of the Humboldt Lumber Industry, 1850–1950*, was invaluable. Additional resources include oral histories, newspaper articles, and other primary sources. Finally, the authors hope their work will inspire future historians.

INTRODUCTION

At the dawn of the 20th century, Humboldt County's redwood mill owners were confident about their future, and with good reason. In 1914, Charles Willis Ward noted in his book *Humboldt County, California: the Land of Unrivaled Undeveloped Natural Resources on the Western Rim of the American Continent* that:

> The lumber industry is easily the greatest of all Humboldt County industries. It is the greatest because the supply of standing timber per acre is the greatest and the reason for this is that the grandest of all trees, the giant redwood, abounds in Humboldt County, the choicest of all forests of this wonderful tree being within its borders. The average cut per acre of redwood lumber is more than 50,000 feet.
>
> Nowhere can one find so many board feet in a single tree, and nowhere so many wonderful trees to an acre. Think of a tree twenty-two feet in diameter and four thousand years old, straight, tall and clear! It stands without a limb to deface its perfect symmetry for two hundred feet above the ground. Such a tree will produce an enormous amount of building material.

Redwood was a desired lumber due to several characteristics. The mammoth tree produced rot-resistant lumber with a rich red color. The wood's beauty made it desirable for decorative purposes. Doors and molding, piano cases and sounding boards, and even violins were made from redwood. Easily split, redwood was made into shingles, grape stakes, and railroad ties. The ties were sought after, as the tannin-filled wood was resistant to insects. Redwood was also used to make water tanks and pipes. Additionally, the burl wood was made into bowls and plates for decorative and souvenir purposes.

Perhaps most reassuring to lumber mill owners near the turn of the 20th century was the amount of redwood timber still standing. In 1914, Ward noted that in about 20 years the red cedar stands of Oregon and Washington would be depleted, while in Humboldt County there were 45 billion board feet of standing timber. These trees were "conservatively valued at over one hundred million dollars." Despite Ward's glowing words, most large redwoods close to Eureka and Arcata had been harvested by the turn of the 20th century. Large stands of redwoods along the Eel River and South Fork of the Eel had not been harvested due to their remote locations but were now accessible by railroad, providing new timberlands for mills. The Van Duzen watershed and portions of watersheds to the north were also filled with virgin timber.

Large mills operated by single owners dominated the lumber scene in the early 1900s; however, larger numbers of corporations were making their presence felt. Corporate mills were less invested in their employees and often treated workers in a cavalier manner, leading to labor unrest, strikes, and unionization. The corporations also actively engaged in buying up smaller mills, expanding holdings, and eliminating competition throughout the 20th century. The Pacific Lumber Company

of Scotia, Hammond Lumber Company in Samoa, Northern Redwood Company of Korbel, and Dolbeer and Carson Mill of Eureka were the largest mills in 1914. Charles Ward also noted smaller mills of "lesser capacity are the Eel River Lumber Company, (at Newburg), the Holmes Eureka Lumber Mill, the Metropolitan Lumber Company and the extensive shingle mills of W.G. Press."

Timber companies constantly sought ways to improve their product and yield from a tree. As early as 1906, paper pulp was being made from redwood bark. Additionally, technological advances increased the number of redwoods felled in a season. Advertising efforts of the Lumber Makers Association were paying off, with increased demand for redwood lumber. Redwood in the form of boards, shingles, or railroad ties was shipped to distant ports in China, Australia, Hawaii, and South America. San Francisco was a common destination for many ships leaving Humboldt Bay. Transportation methods for both the redwood logs and finished products would continue to evolve and change during the 20th century, most notably with the growing use of trucks in the 1930s and 1940s.

Due to the region's remote location, mill owners experienced many challenges both in getting their products to market and in transporting logs to mills. The first solution had been to build railroads. These lines connected woods operations to mills. One line, the Eel River & Eureka Railroad, built by timber company owners John Vance and William Carson, connected Eureka and Alton in the 1880s. In 1914, the Northwestern Pacific Railroad linking Eureka to San Francisco was completed, allowing cheaper and easier transportation to markets. The line proved very profitable for its owners during the first half of the 20th century.

Both world wars impacted the industry. Young men were called up to fight for their country, while older men filled in for them at sawmills and in lumber camps. During World War I and World War II, women worked at the mill in Scotia and other mills around the county, filling in for absent soldiers. The wars also resulted in technological changes in woods and mills operations. Trucks that had seen service in World War I were brought to work in the woods. Nash Quads were soon to be seen on the early highways of Humboldt, hauling split products such as shingle bolts or railroad ties, as these early trucks were too small to handle redwood logs. Additionally, mechanizing the sawing process in the woods began with enormous two-handed dragsaws, leading to the modern chain saw. The tractor crawler, or bulldozer as it was more commonly known, began to be used in the woods following World War I. Technological advances from the war, including tanks with large tracks to roll on, were translated to the dozers that eventually replaced the steam donkey as a means to haul logs to a landing.

A number of natural disasters in the 20th century affected the redwood lumber industry. The first was the 1906 earthquake, which destroyed many homes and communities in Northern California, in addition to the destruction of much of San Francisco. The earthquake caused significant damage to towns in Humboldt, including Hammond's mill at Samoa on Humboldt Bay. Conversely, the devastation meant an increased demand for lumber. The mills responded with even greater shipments of lumber south.

One consequence of rapid harvesting of redwoods was the formation of the Save the Redwoods League (SRL). The founders of the league, Madison Grant, John Merriam, and Henry Osborn, realized the trees would soon be felled to the point of extinction if the rate of harvesting continued unabated. The SRL formed in 1918, purchasing its first grove in 1921. Dedicated to Colonel Bolling, the first high-ranking American officer killed in World War I, the grove is located two miles south of Myers Flat. The grove was the first of many acres purchased by the SRL in Humboldt County and is now encompassed within the 50,000-acre Humboldt Redwoods State Park. This park protects the largest stand of old-growth redwoods left in the world.

The Save the Redwoods League was not the only group interested in long-term management of redwood lands. As early as the 1920s, redwood lumber companies worked to replant logged-over lands, often from their own greenhouses. The Pacific Lumber Company, for example, had a large operation for growing trees. Local residents were hired to bring in redwood cones so seedlings would have characteristics of old-growth redwoods. The redwood lumber companies

also benefited from research about trees provided by scientists at the University of California, Berkeley. Forestry professor Emanuel Fritz was instrumental in influencing companies to work towards more environmentally sound logging practices and forest management.

Disasters in the 20th century included rampant wildfires, many caused by logging practices themselves. This in turn led to the creation of the California Department of Forestry (CDF), which located fire stations throughout the county to protect the natural resources. The CDF also installed fire lookouts on Pratt and Grasshopper Mountains in southern Humboldt. These lookouts were staffed during summer months with personnel watching for signs of fire. Large companies also started patrolling their lands, encouraging employees to be fire conscious.

The lumber industry was vulnerable to economic pressures of the 20th century. The Great Depression of the 1930s witnessed the closing of many mills. The Holmes-Eureka Mill was the site of a violent protest. In 1935, a total of 300 laborers at Humboldt County mills went on strike for shorter hours, better pay, and the right to unionize; they were working 10 hour days, six days a week, for 35¢ an hour. This strike turned deadly on June 21 when three striking workers were shot and killed by police.

In total, the first half of the 20th century was an era of growth and prosperity for mill owners, despite economic and environmental forces. The era was also marked by lumber companies working to utilize as much of the logged tree as possible, to help the company survive. For example, new uses for sawdust led to the manufacturing of "Pres-to-logs." The era also saw the change from a paternalistic approach to workers to a more capitalist focus in which employees were seen more in terms of the wages they were paid. This dynamic era required companies to begin to think in terms of long-term success. Their efforts included reforestation, logging second-growth trees, and acquiring extensive acreage, including complete watersheds, to ensure an ongoing supply of trees to harvest. Lumber companies began to think in terms of a sustainable yield instead of logging all the trees possible and moving on to another site. It was an era of contradictions, making it one of the most interesting times in the logging history of Humboldt County.

In exploring the mills of Humboldt in the early 20th century, the authors have chosen a chronological approach. Each decade is examined to illustrate various forces at play during that era, including technological advances as well as labor disputes that rocked the region. Every attempt has been made to include all the mills in the county during this period, but the authors were limited by the photographic record. The goal is to increase understanding of lumber industry operations and of how redwood logging affected the region. The authors are donating their royalties to the Fortuna Depot Museum.

One

THE TURN OF THE CENTURY

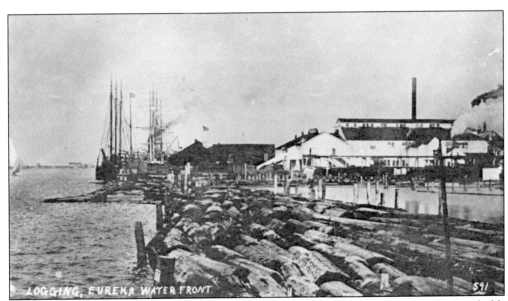

By the first decade of the 20th century, the redwood industry was firmly ensconced in Humboldt County, driving the local economy. Many fortunes had been made, including those of William Carson and James Dolbeer, whose Bay Mill is pictured here. These lumber barons had made their fortunes from the "red gold" of the redwood forests over the previous five decades. (FDM.)

The 20th century was marked with disasters that influenced the demand for redwood lumber. The first natural disaster was the 1906 earthquake. The damage done in San Francisco and in California's northern counties led to a dramatic increase in the amount of lumber production in the region. (FDM.)

The 1906 earthquake and subsequent fire destroyed business buildings and personal dwellings alike, and the demand for lumber for rebuilding was immediate. The mills in Humboldt responded by running two or even three shifts per day to accommodate the need for building materials. Redwood lumber was in high demand. (FDM.)

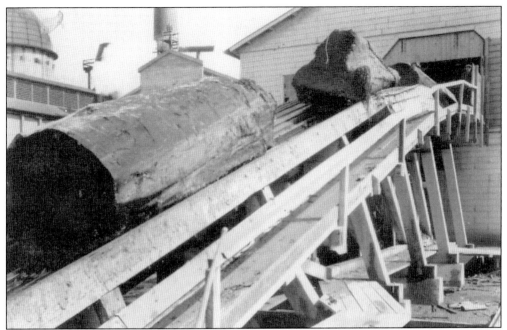

By the 1910s, many early redwood lumber mills closed after having cut down easily accessible redwoods. These mills, and the land they owned, were purchased by larger operations, such as The Pacific Lumber Company (with "The" capitalized, often shortened to TPL Co.) in Scotia; Dolbeer and Carson Lumber Company in Eureka, whose log haul is pictured; and Hammond Lumber Company in Samoa. This trend continued throughout the 20th century. (UCB.)

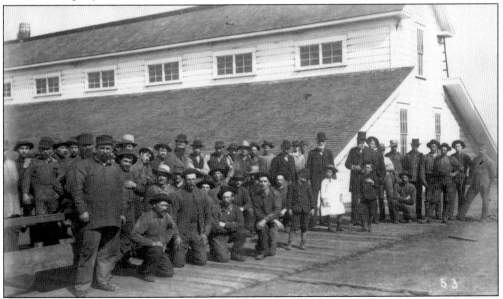

The oldest of these big mill operations was Dolbeer and Carson, beginning in 1864 on Humboldt Bay in Eureka. John Dolbeer and William Carson were partners in the enterprise, with Dolbeer watching over sales and management from offices in San Francisco and Carson in charge of the mill. Photographed with employees and their families, Dolbeer stands behind the girl in the white dress and Carson sports a top hat. (HSU.)

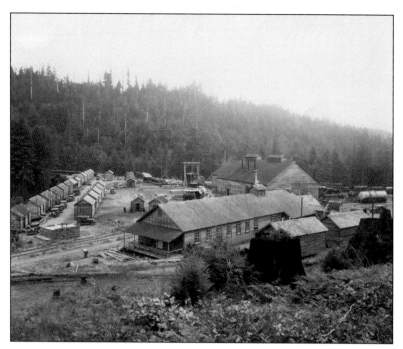

In 1900, Dolbeer and Carson Lumber Company owned 16,270 acres of redwood timberland valued at over $1 million. Its assets in the mill and ships totaled the same amount. John Dolbeer died in 1902 and Carson continued operations until his death in 1912, when his son inherited the business. Shown is their Elk River woods camp. (HCHS.)

William Carson embodied the epitome of the patriarch of the woods who looked after his employees. Not only did he employ his workers to build his famous mansion (center), he also kept them employed in the depression of 1893. Further, he voluntarily shortened his company's work hours, opposing changes in working conditions advocated by Andrew B. Hammond, who began operating the Vance mill in 1903. (HCHS.)

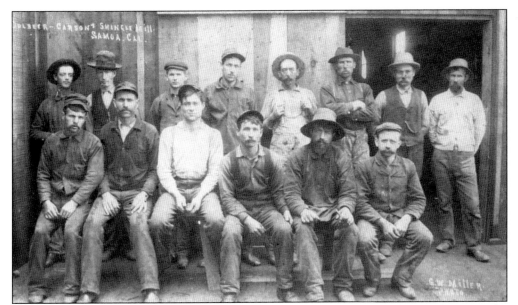

In his Stanford University master's dissertation, H. Brett Melendy called Dolbeer and Carson "the best mill for which to work. It . . . did not have a company store . . . in addition, the employees felt that the owners bent over backwards to be fair to the workers." Around 1900, the mill employed 100 men, producing 100,000 board feet a day, with another 100 working at the Lindsey Creek woods camp. (HSU.)

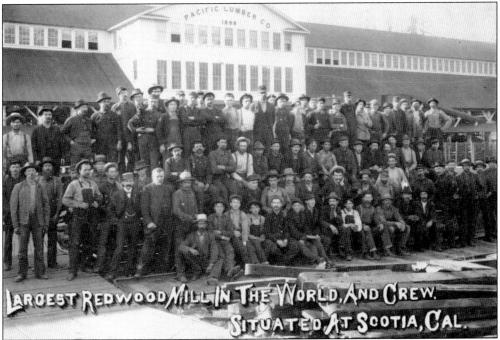

The company that survived the longest in the 20th century, eventually purchasing the assets of Dolbeer and Carson, was the Pacific Lumber Company of Scotia. Owned originally by Alexander Macpherson and Henry Wetherbee, owners of the Albion Lumber Company in Mendocino County, the company was sold several times without going through any name changes. (HSU.)

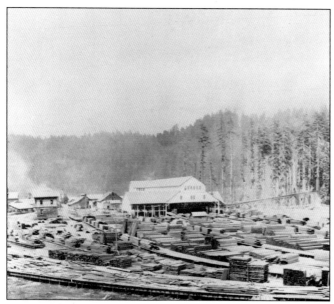

Macpherson and Wetherbee purchased several thousand acres of redwood lands in 1869, building a mill in 1886. The first mill town was called Forestville, renamed Scotia (in honor of Nova Scotia) in 1888. The owners encouraged employees to sign up to homestead government land and then sell the property to the company. In this way, the company became owners of large tracts of trees along Bull Creek and other watersheds. (FDM.)

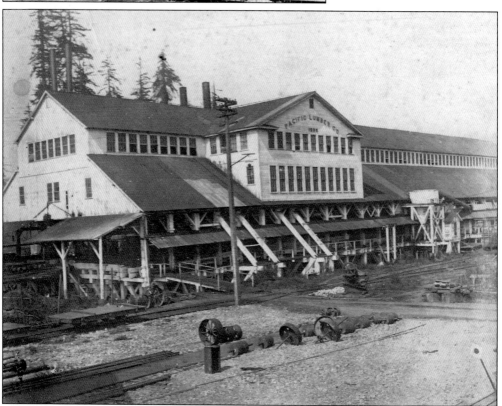

The early 20th century was a turbulent time for the Pacific Lumber Company's ownership. In 1901, A.B. Hammond attempted to buy out the mill by acquiring the minority stock. He failed; instead, the mill was bought out by H.C. Smith of Minnesota in 1902. Smith was experienced in the Minnesota lumber business and sought to add to his wealth by expanding into the burgeoning redwood industry. (Phil Dwight.)

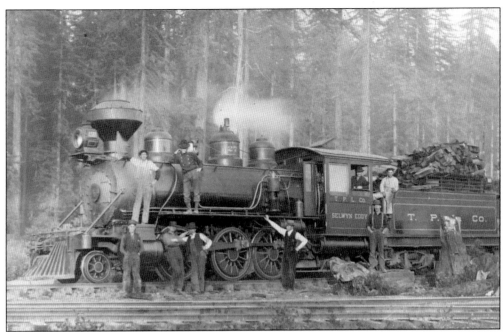

H.C. Smith also bought out Excelsior Redwood Company's lands, railroad, and mill near Freshwater. Smith resigned in a 1904 corporate shake-up, and Selwyn Eddy became president. The company reorganized in 1905, consolidating the Freshwater and Scotia operations. At this time, the company became known as The Pacific Lumber Company (TPL Co.). The new owners were from Chicago, Detroit, and Saginaw, Michigan. Shown is TPL Co.'s locomotive named after Selwyn Eddy. (FDM.)

The family of Eddy's business associate Simon Murphy became controlling owners of TPL Co. in 1905 and managed the mill into the 1980s. Simon Murphy was a Maine lumberman and later a financier in Detroit, Michigan. Similar to William Carson, Murphy had grown up in the lumber industry, and, like A.B. Hammond, owned many lumber companies in eastern states. (FDM.)

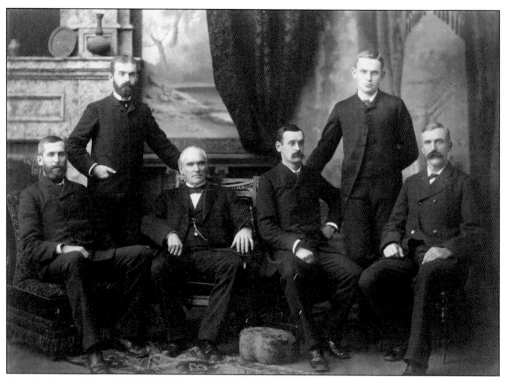

Murphy began to purchase TPL Co. stock soon after becoming associated with the company. Two months after his death in February 1905, his family had controlling interests in the company's operations. Son William Murphy was to take control of the company for the family. In this Murphy family picture are, from left to right, Charles, Albert, Simon Sr., Frank, Simon Jr., and William. (Horseshoe Bay Farms.)

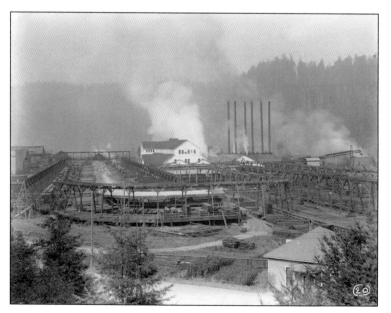

William Murphy, the first college graduate of the family, applied his skills in running TPL Co. According to the *Los Angeles Herald*, in 1909 the company had assets of $1 million, owning 65,000 acres of redwood timberland. Other holdings included five large steamships for transporting lumber to markets. TPL Co.'s railroad line and locomotives brought logs to the mill. (FDM.)

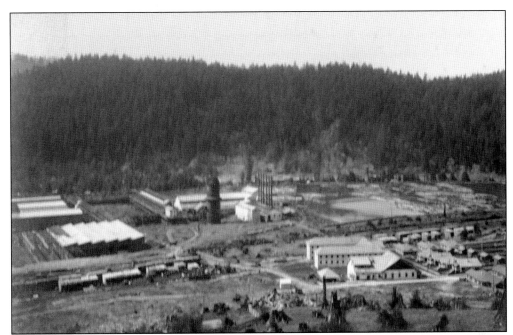

In 1910, TPL Co. built a new mill, known as Mill B. Put into operation in July of that year, it had a capacity of 500,000 board feet of lumber per shift. At the time, the mill was operating two shifts each day. According to the *San Francisco Call*, the lumber would "be shipped to San Francisco and Wilmington [Los Angeles Harbor]." (Phil Dwight.)

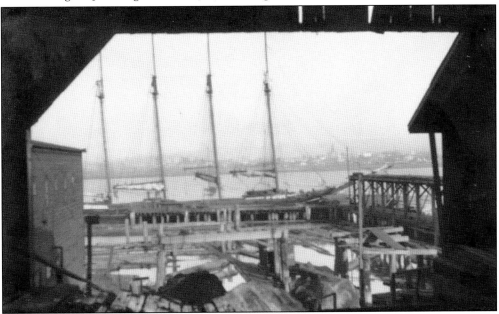

Another mill that dominated Humboldt's 20th-century timber industry was at Samoa, across the bay from Eureka. Originally built by John Vance in 1893, the operations were purchased by Andrew B. Hammond in 1903 and renamed Hammond Lumber Company in 1907. University of California, Berkeley forestry professor Emanuel Fritz took this photograph from the Samoa mill's log haul in 1920. (UCB.)

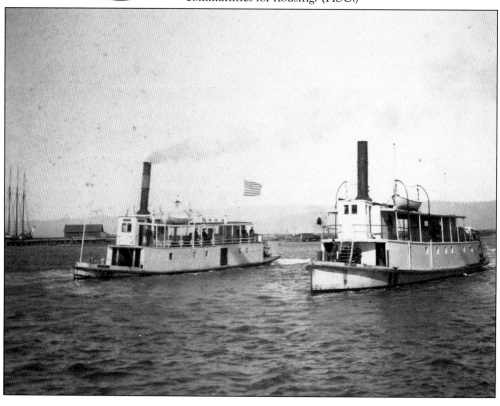

When A.B. Hammond purchased the Vance mill he was 50 years old and had developed a business model based on tycoons such as Rockefeller and Carnegie. To maximize his profits, Hammond controlled most aspects of his operations. His crews were fed on beef, pork, and chicken his employees raised, and he owned the vessels bringing his employees to work and the ships taking his products to market. (Archives and Special Collections, Mansfield Library, University of Montana.)

Hammond's ferries crossed the bay daily, and he charged his employees for traveling to and from work. The alternative was living in one of Hammond's company houses, or barracks for single men, in Samoa. Hammond was the first lumber company owner on Humboldt Bay to institute a company town. Prior to the 1900s, employees of mills around the bay relied on local communities for housing. (HSU.)

The ferry also allowed mill workers to enjoy the pleasures of Eureka. One employee, Fred Pritchard, standing at left beside friend Charlie Philbert, recalled a 1909 incident when a drunken friend fell from the ferry into the bay. Pritchard timed how long his friend was underwater: nearly three minutes. Pritchard felt that the alcohol accounted for his friend's survival. Pritchard and his colleagues' wages were $1.75 a day. (FDM.)

The ferries were built in the nearby shipyard that Hammond had purchased from Hans Bendixson. Hammond continued to use the shipyards through the beginning of World War I, building ships to haul lumber to his lumberyard in Los Angeles as well as other destinations. During World War I, the shipyard also began to produce steel ships under the auspices of James Rolph, mayor of San Francisco and later governor of California. (HSU.)

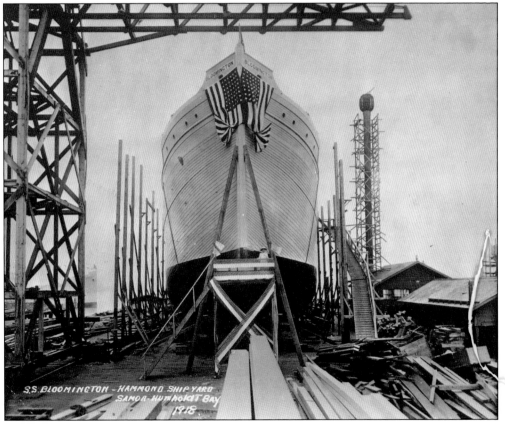

S.S. BLOOMINGTON - HAMMOND SHIP YARD
SAMOA - HUMBOLDT Bay
1918

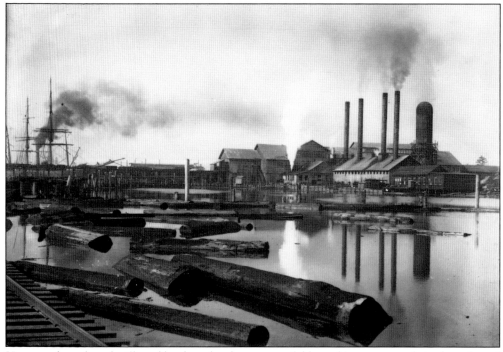

Hammond purchased mills and lands as they became available, seeking a monopoly in the redwood industry. In 1903, he had 30,000 acres of timberland. Nineteen years later in 1921, the company controlled 87,000 acres of timberland. Hammond focused his energies on buying land in the Mad River drainage. Shown is Hammond's mill at Samoa. (HSU.)

Hammond instituted many cost-saving policies, often copied by other mills. Among changes affecting the entire timber industry were going to year-round operations in the woods and working longer days in mills. Prior to these changes, woods operations shut down during wet winter months. A great deal of environmental damage was caused by this one decision, as seen here. (HCHS.)

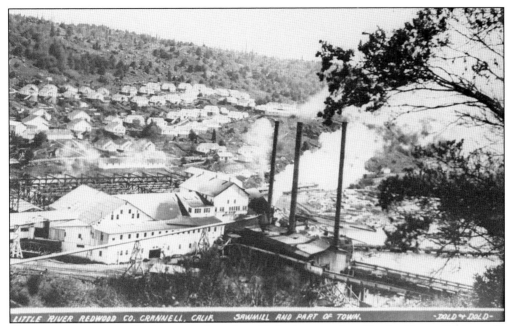

Company towns were utilized extensively at the mills farther away from Eureka. Crannell (pictured), Falk, Korbel, Metropolitan, and Scotia all were company towns. These companies also had their own stores; often workers were paid in scrip, which could only be used at the company store and to pay the rent on the company-owned houses. (HSU.)

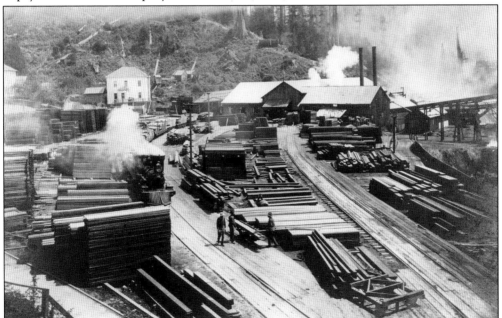

Noah Falk opened the Elk River Mill and Lumber Company in 1882, naming the company town supporting the mill Falk. When he sold out in 1904 to a conglomerate based in San Francisco, the town and mill retained their names. The mill closed in 1938, unable to survive the economic depression and lack of trees to supply the mill. The town was also abandoned at that time. (HSU.)

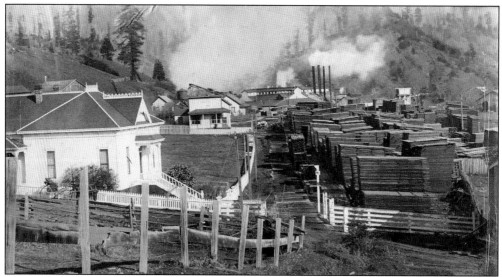

A lack of trees and no market for lumber forced the closure of many mills during the 1930s. For example, the Eel River Valley Lumber Company, opened in 1884 at Newburg near Fortuna, closed in 1931 after having logged off all of its timber holdings. The mill operated along Strong Creek and logged in the creek drainages surrounding Fortuna. (HCHS.)

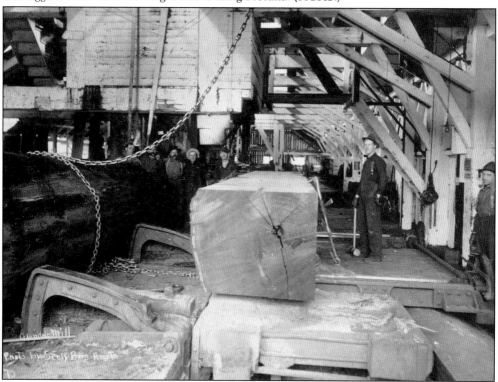

The Glendale Mill near Blue Lake closed in 1911, having depleted its timber holdings. Originally opened in 1885, the mill had been operated by the children of Isaac Minor as the Minor Mill and Lumber Company until its closure. The mill's double headrig saw, needed to saw the large logs, is shown. (HSU.)

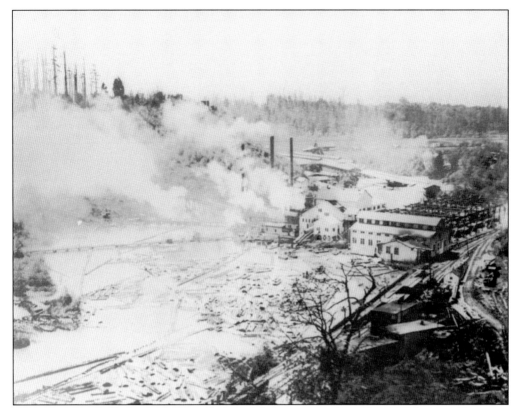

Located at Crannell, the Little River Redwood Company was formed in 1893 by a conglomerate of owners from Tonawanda, New York, and Ottawa, Canada. Operations did not begin until 1908. The mill, timberlands, and town were merged with the Hammond Lumber Company in 1931. Crannell remained a company town until 1969 and was the setting of four movie adaptations of Peter Kyne's novel *The Valley of the Giants.* (HSU.)

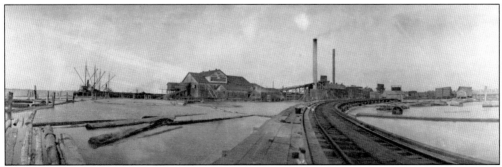

The Bayside Mill and Lumber Company in Eureka was originally the Flanigan, Brosnan & Company mill. The *San Francisco Chronicle* reported in 1905 that the mill was purchased by E.T. Collins, "a millionaire lumberman of Pennsylvania and his associates. The deal includes the mill . . . and 2000 acres of the most valuable timber in the county." In 1929, Dessert Redwood Company purchased the mill, selling it in 1937 to Hammond Lumber Company. (HCHS.)

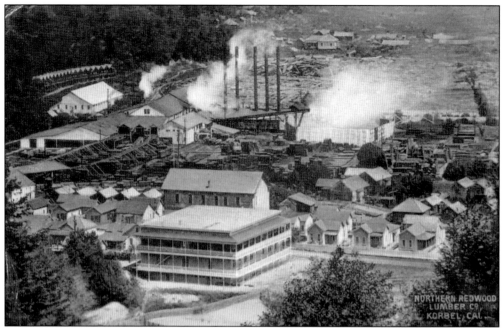

Northern Redwood Lumber Company was created when the Riverside Mill at Blue Lake merged with Korbel mill holdings in 1902. The two mills continued operations with a combined production capacity of 200,000 board feet a day. In 1905, the company had holdings estimated at two billion feet of redwood lumber and had extensive railroad lines accessing its woods operations. (HRIA.)

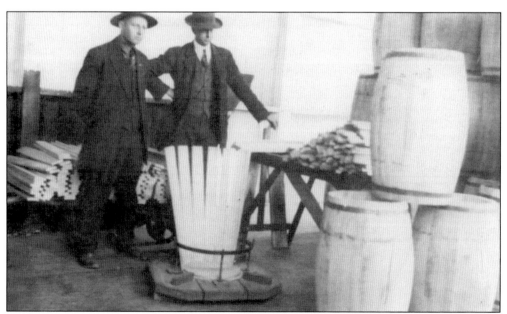

California Barrel Company, an Arcata-based branch of a San Francisco parent company, was an important part of Arcata's economy from its inception in 1902. By 1920, the mill turned 150 cords of wood a day into boxes, barrels, and containers. The barrels pictured were destined to be ginger barrels and were sent to the Philippines. (UCB.)

Holmes-Eureka's mill opened in 1903, when J.H. Holmes purchased a mill site from William Carson. An advantageous site, the wharf allowed shipping from the bay and lay along the route of the Northwestern Pacific Railroad (NWP). Much of the timberlands of Holmes-Eureka were located along the Eel River, so the company relied on the NWP for shipping and to bring logs to the mill. (UCB.)

Metropolitan Lumber Company was formed in 1904 by a conglomerate of timber men from Michigan and Wisconsin. Located south of Alton, the mill's timberlands were west of the Eel River, encompassing 3,600 acres of timber in the Slater Creek Drainage, accessed by a summer railroad bridge. The mill operated until 1925, closing after having logged off its timberlands. (HSU.)

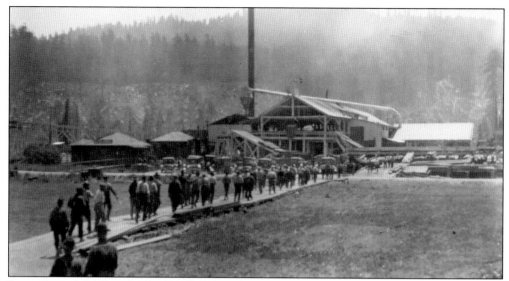

Percy Brown's Mill at Stafford milled shingles, lathes, molding, and doors. Built in 1919, the mill featured a circular headsaw and bandsaw. The workers shown are returning to work after their noon meal at the cookhouse, where they had also heard a Chatauqua speaker. Chatauqua speakers traveled extensively, giving lectures about science, public issues, international relations, and literature. (UCB.)

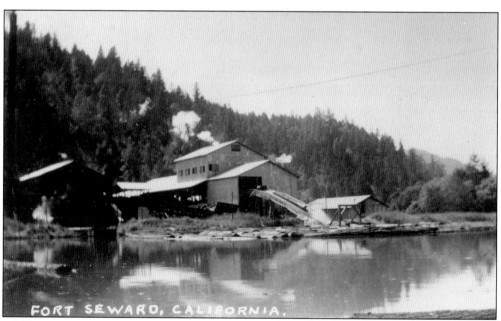

In 1914, a mill opened catering to residents of the Fort Seward region in southern Humboldt. The completion of the Northwestern Pacific Railroad that year allowed for an influx of settlers to the area. B. Melville was the owner of the mill, and he also acquired the rights from the government to log on government property in nearby Trinity County. (HCHS.)

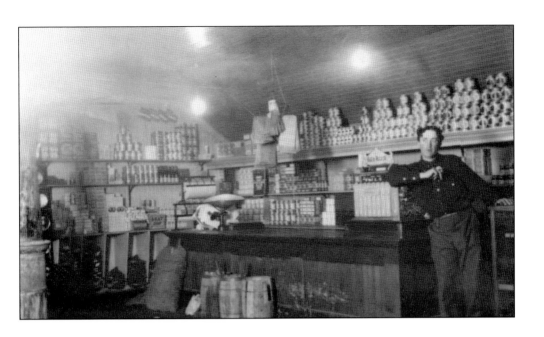

Supplying Humboldt's mills with logs were lumber camps operated by the various companies. Cabins, cookhouse, office, and shops were built on skids, or later on railroad cars, for ease of movement. Many camps included a company store (above), allowing employees to purchase anything they might require. The entire camp would be moved to the next logging show (the term used for the location of logging operations), where operations would begin again. Shown below is the railroad car camp for TPL Co.'s operations at Freshwater. The three cars at right, attached end to end, form the camp kitchen. (Both, UCB.)

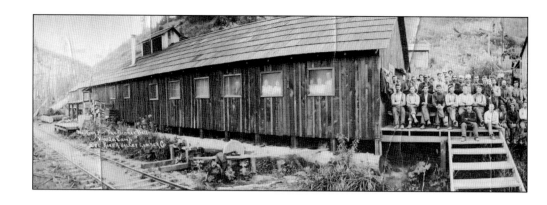

The *Fortuna Advance* in 1915 reported the challenges of moving the Eel River Valley Lumber Company's woods camp. "John R. Crank, with a crew of assistants started the work . . . of moving the Newburg logging camp from its present location east of this town to a point about a mile and a quarter further east. The railroad has already been completed to the site of the new camp and cabins in the old camp will be loaded onto the logging cars and transplanted to the new site. In addition to moving the cabins Mr. Crank will erect a new cookhouse. . . . As soon as the cookhouse is completed the logging crew will be shifted to the new camp as logging in the old woods camp is about to end." (Above, Dave Smeds; below, HCHS.)

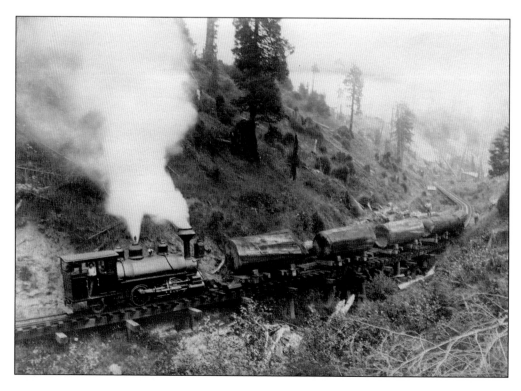

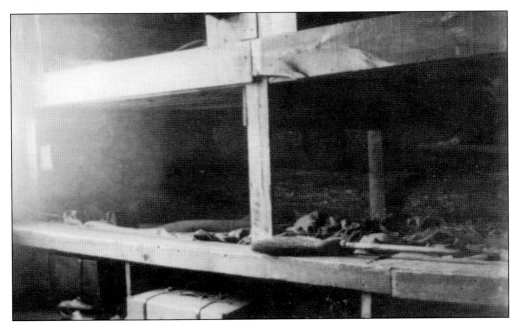

Life in camps was not easy. Whether from the rain, isolation, challenging work, or simply small group dynamics, one winter night an employee of the Masson Mill shingle camp, John Chism, formed the "impression that his visitors and his cabin mate were 'making fun' of him. He armed himself with a pick-a-roon, an implement used in the handling of shingle bolts, and charged the crowd. . . . The visitors escaped through the door and his mate escaped being pick-a-rooned by diving through the window." Chism was taken to the county jail, where he "to a certain extent regained his right mind," reported the *Fortuna Advance* in 1917. Shown above are bunks in a woods cabin, illustrating the frequently cramped quarters and lack of material comforts. (Above, UCB; below, HSU.)

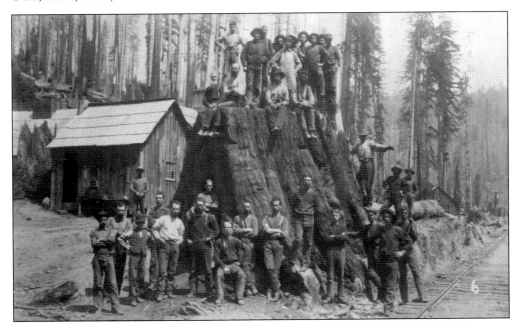

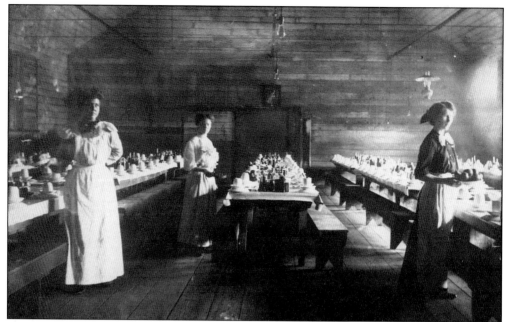

The camp cookhouse provided workers with breakfast, lunch, and dinner. After Hammond introduced the notion of working year-round, camps also provided holiday dinners. In 1914, for example, the Holmes-Eureka Lumber Company logging camp at Holmes Flat prepared a Thanksgiving feast for its woods crew, which included decorating the dining room, as reported in the *Fortuna Advance*. Camp chef Billy Chricton prepared "Turkey Giblet a la Reine Soup, Fruit Gelatine, Potato Mayonaise, Celery en branch, German Piccalilli for salads, Turkey Giblets with rice, Apple Fritters with Butter Sauce, Stuffed Young Turkey with Cranberry Sauce, Loin of Pork with Apple Sauce, Mashed Potatoes, Sugar Corn, Asparagus, Pumpkin Pie, Mince Pie, New England Plum Pudding, Hard Sauce and Brandy Sauce, Hermits Gold and Silver Cake, Fruit Cake, Mixed Nuts, Raisens en Branch, MJB Coffee, Tree Tea, Milk and Cigars." (Both, HSU.)

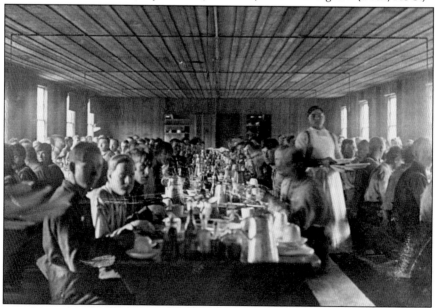

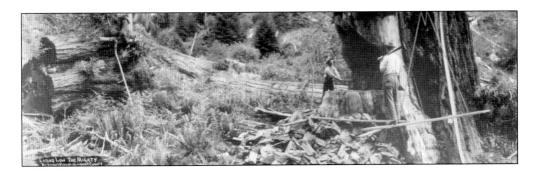

Lumberjacks consumed large quantities of food due to their work's physical demands. Teams of choppers chopped an undercut above the butt swell, first hewing through the fibrous redwood bark, up to a foot thick. Staging "springboards" were built to get above the dense wood compressed by the weight of the tree at its base. This practice continued through the early 20th century, until dragsaws became more efficient. Horizontal cuts, including the back cut, were made with the double-handed "misery whip" saw in the early 1900s. Tree felling remains one of the most dangerous moments in a hazardous profession. Falling branches, called "widow-makers," were one peril. In 1912, the *Fortuna Advance* reported, "Sam Aldrich, a well-known woodsman of Holmes was instantly killed . . . by a falling limb which struck him in the head and crushed his skull." (Above, Library of Congress; below, HCHS.)

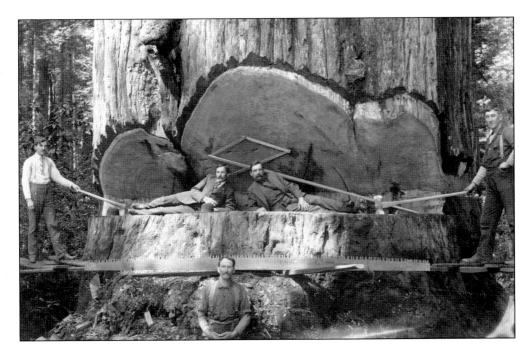

Once felled, logs were cut or bucked into shorter lengths. By 1910, a dragsaw was often used to do the bucking. The top of the tree was cut off and left in the woods. The rest of the log was cut into lengths determined by how the log was being hauled to the mill, usually by railcar until the 1930s, when trucks were utilized. (HSU.)

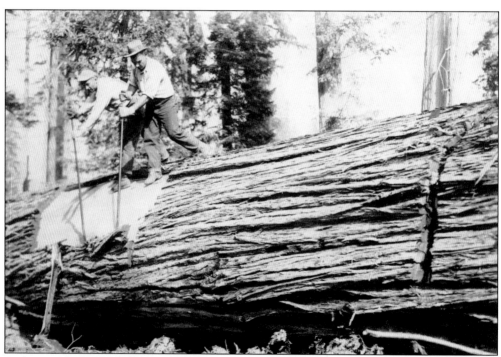

Peelers, using long metal bars, slipped the bark off. One peeler, Sam Stockton, made friends with the choppers so they would fall the log in a way to give him easier access for peeling. Log peeling began when oxen hauled logs and slowly changed as other technologies began to be used to haul logs to landings. Peeled bark was left in the woods, to be burned along with other debris. (HSU.)

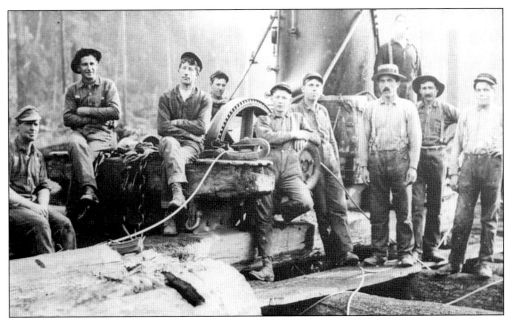

All woodsmen wore caulked or "cork" boots, with nails driven into them giving better traction; cork boots gave peelers extra purchase on slippery logs. Additionally, loggers would stag (cut) their pants or roll up their cuffs to prevent limbs and other debris from catching them, potentially tripping the men as they worked in the woods, as this Hammond woods crew illustrates in 1910. (HSU.)

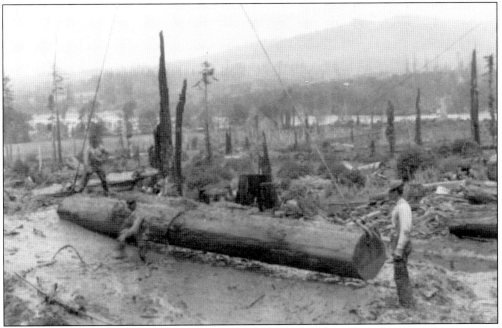

After logging, crews set fire to the woods, on the theory that this allowed for easier log removal. Working in all weather conditions did not always allow for smooth yarding, as shown in this 1915 image of a Holmes-Eureka landing. The crew is using a crotch line with hooks on the end to move a log, the cables connecting to guy wires, a spar tree, and power provided by a steam donkey. (UCB.)

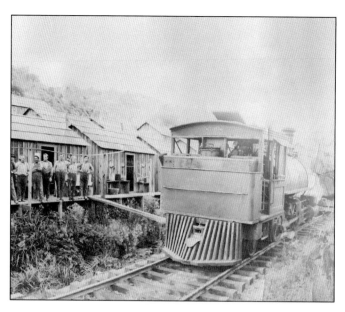

Steam technology developed in the 1800s continued to power redwood mill and woods operations into the early 20th century. The steam donkey engine invented by John Dolbeer was used to yard logs to landings and load logs onto railcars. Lumber company railroads connected woods operations with mills. This locomotive shown at one of Newburg's logging camps was another invention of John Dolbeer and functioned both as a donkey and a locomotive. (Dave Smeds.)

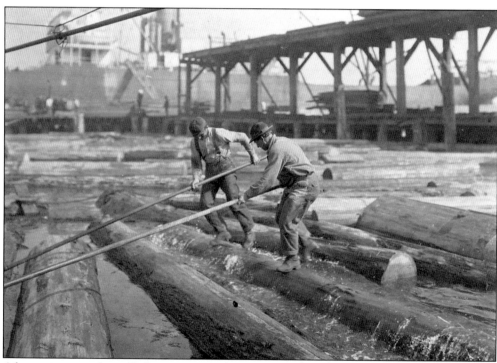

After arriving at the mill, logs were stored in "ponds" until sawn. Mills along Humboldt Bay formed ponds by sectioning off a portion of the bay. Other mills dammed local watercourses. The captain of the pond selected which logs were sent into the mill. The other men who worked there were called pond monkeys, as they needed to be nimble to jump from log to log, as shown at Hammond's pond at Samoa. (HCHS.)

Once pushed onto the log haul, the process of making lumber began. TPL Co. was renowned for having the most modern mills, with a daily output of about 500,000 feet of lumber. In 1914, the *Fortuna Advance* noted that P.M. Cook, Fred Philipp (left), and Wallace Carter, "all sawyers in the old mill at Scotia . . . cut more than 285,000 feet of lumber" in a 10-hour period. Sawyers held an important post, determining how to saw a log to get the most lumber. The saw filer had an equally crucial position, also requiring specialized knowledge. Pictured below are saw filers for Mill A in the saw filing room on the second floor of the mill at Scotia in the mid-1910s. Hugo Philipp stands with arms crossed at left. The filer sharpened every other tooth of the saw before reversing the roll and repeating. Thus, the correct beveled angle on the saw was filed, making it cut straight. (Both, Phil Dwight.)

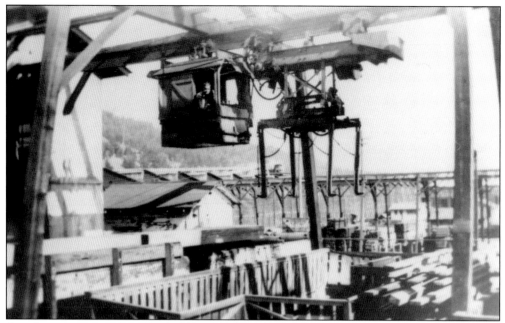

Another improvement in Humboldt's sawmills was the addition of a monorail system. In 1910, TPL Co. began construction of a monorail to transport lumber from the mill to drying kilns and then to warehouses where lumber was stored until it was milled again to make finished boards. The TPL Co. monorail operator's booth is shown. In 1914, Hammond Lumber Company installed its own monorail system. (FDM.)

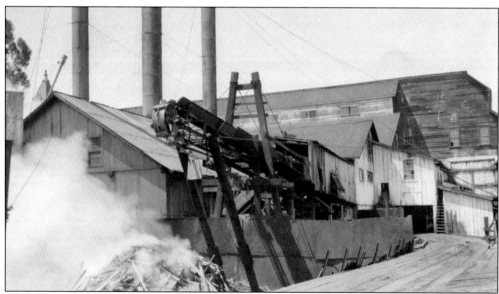

One technological advance that changed the landscape of mills was the addition of burners. Large burn piles, such as the pictured open fire pit at Dolbeer and Carson, were constrained inside a structure so the fire could power the mill, as well as being a safer place to burn scrap wood and by-products of the mill. (UCB.)

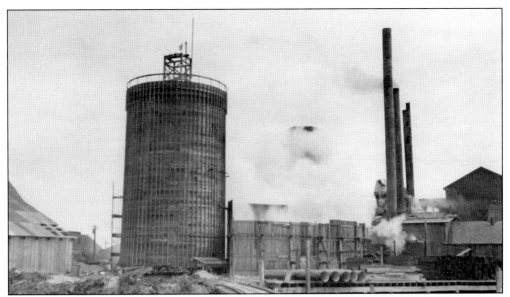

The first burners, tall cylinders made of brick, were developed in Michigan. This burner is being built at the Holmes-Eureka mill in the mid-1910s. Although Eureka did have brickyards in the early 20th century, for Humboldt mills located far from these brickyards, the expense of shipping the needed bricks made brick-lined burners costly. (UCB.)

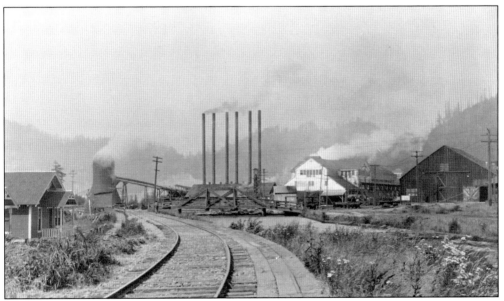

In 1915, Colby Engineering, of Portland, Oregon, created a new burner design. Flared at the base, the structure became known as a teepee burner. A screen over the top kept sparks contained. Lining with two sheets of metal eliminated the need for a brick liner, reducing costs. Teepee burners soon marked the locations of the region's lumber mills. During World War II, though coastal communities were under a black-out order, burners continued to glow brightly throughout the night. (FDM.)

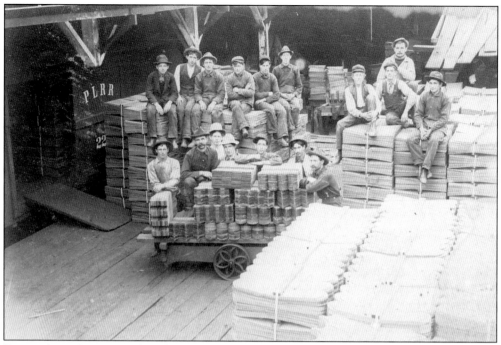

During the early 1900s, redwood was also logged to make shingles, railroad ties, and grape stakes, products split from the tree's friable wood. In 1913, there were 25 shingle mills in Humboldt County, some part of larger companies' operations. TPL Co., for example, had a dedicated mill, shown above, for sawing shingles. Typical of independent mills was Frank Beckwith's shingle mill, below, located east of Carlotta along Cummings Creek. His operation was described in the *Times-Standard* in 1971 when surviving employee Johnny Friend reminisced about the mill. In 1910, Friend was an 11-year-old orphan working the same 10-hour day as the rest of the crew, six days a week. He was responsible for "hooking shingle bolts to the end of a cable in the woods operations." He was paid $30 a month, along with room and board. The top hand in the mill received $60 per month. (Both, FDM.)

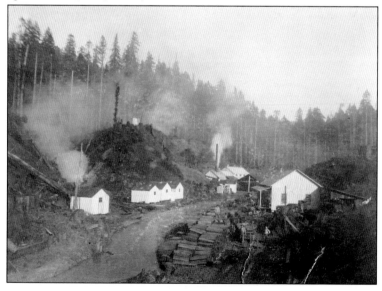

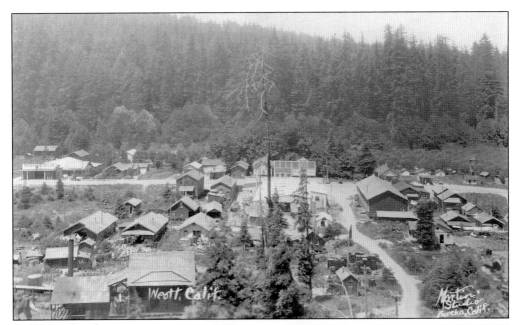

In 1910, railroad construction brought easy transportation of raw materials and finished products to Dyerville, resulting in the expansion of the split product industry into the region. Ernest McKee operated several shingle mills in the area. One was located two miles south of Dyerville; a small town sprung up around the mill and was named Weott in the 1920s. The mill is shown in the foreground. (HRIA.)

Railroad tie and shingle bolt camps were also established near Dyerville. Workers split ties from a felled tree before falling another. Shown is a log in the process of being split into ties. Ties were hauled by wagon or by truck after World War I to the train station at South Fork, then loaded by hand onto railcars. In 1913, a total of 8,396,409 feet of ties, with a value of $109,075, were shipped from Humboldt Bay. (UCB.)

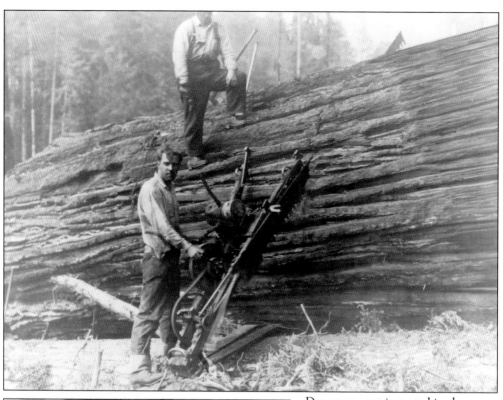

Dragsaws were invented in the 1880s but were bulky and awkward to use. Lighter models became more commonly used after 1910. In 1920, Edward Morris, of Willits, reported in the *Timberman* using dragsaws to complete his contract for 50,000 redwood ties. He observed dragsaws are "of great value as [redwood] is springy and difficult for bucking crews to pull the ordinary saws through." George Sorenson, foreground, is shown next to a dragsaw. (HRIA.)

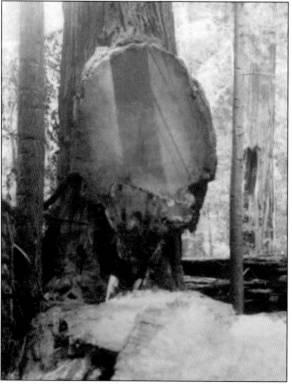

Some operations focused on logging specialty wood. In 1918, the *Fortuna Advance* reported C.M. Hall and C.E. Parkman were cutting curly redwood, a unique decorative wood cut from burls. The *Fortuna Advance* noted that "the first carload of this timber was loaded by crane and shipped east." Burls can be large; one cut in 1935 weighed four tons. (UCB.)

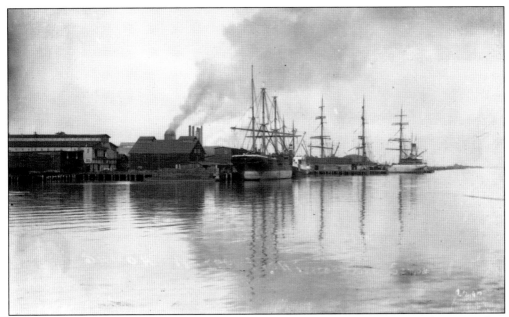

A challenge confronting lumber companies from the 1850s onward was getting product to market. Solutions to Humboldt Bay's rough and dangerous entrance included using specially built boats with shallow drafts and building jetties in the 1890s. Costs were high, thus in 1906, Dolbeer and Carson, Hammond, TPL Co., Northern Redwood Company, Elk River, Occidental, and Bayside mills formed the Humboldt Stevedore Company to help control expenses. (HSU.)

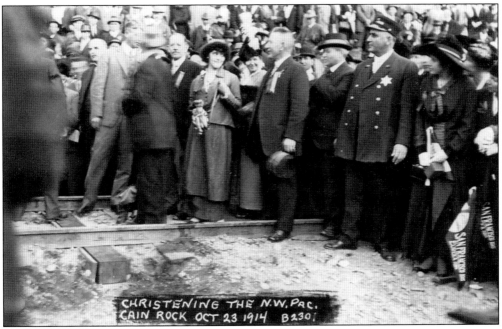

In 1907, the Santa Fe and Southern Pacific Railroads joined forces creating the Northwestern Pacific Railroad (NWP), a line connecting Eureka and San Francisco. Delayed by many challenges, the railroad was completed in 1914. The NWP was profitable; in 1916, revenue from freight on the railroad amounted to $1,703,371, with a net profit of $597 per mile of the line. (HSU.)

World War I's start in 1914 closed many international markets, resulting in shingle mills shutting down, including Humboldt Milling Company, McConnaha Brothers, Fortuna Milling Company, W.F. McIntyre, Ole Hansen, E.G. Ogle, A. Masson & Sons, the Metropolitan Lumber Company, C.W. Williams, and C.A. Kalistrom. Some never reopened, and when a new fire resistant asphalt shingle was created in the early 1920s, the remainder also ceased operations. (UCB.)

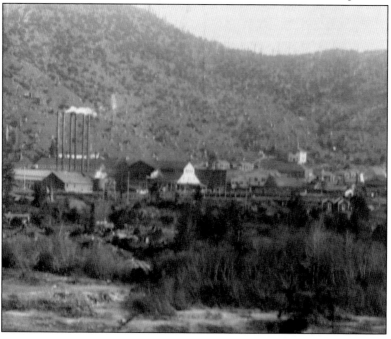

Similarly, World War I affected the lumber industry. Lack of orders caused several mills to shut down, while larger mills curtailed their hours. For example, in 1914, Hammond Lumber's mill only operated nine hours a day, five days a week. TPL Co. operated Mill A at 74 percent capacity and Mill B (pictured) at 78 percent. (Phil Dwight.)

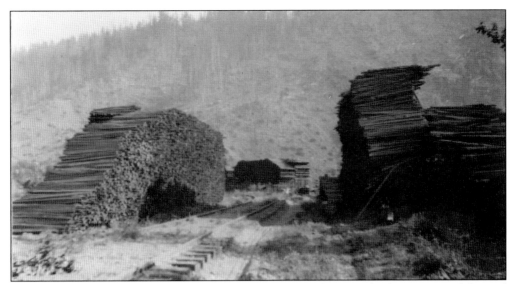

Conversely, when the United States joined the war in 1917, there was both an increased demand for lumber as well as a labor shortage as many men were drafted. In southern Humboldt, women were hired to work in one split products camp. The owner, C. Parkman, commented in the *Fortuna Advance*, the "two ladies are making grape-stakes side by side with great big husky men and they are making good." (UCB.)

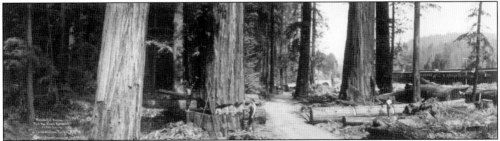

Also affecting the industry was the military's conscription of railroad cars. In the fall of 1917, the *Fortuna Advance* noted, "The shortage of cars is being felt . . . now that the government has commandeered so many for its military preparations. . . . It is especially being felt in the lumber traffic out of this county." Shown is a Northwestern Pacific train near Dyerville. A logging crew works nearby. (Library of Congress.)

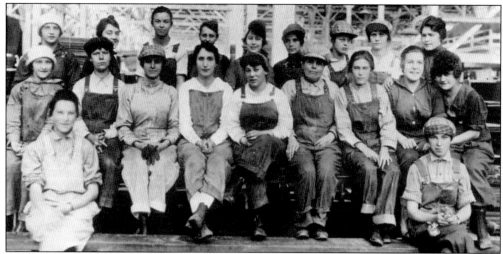

TPL Co. employed an all-female crew to make cigar boxes from redwood as shown in this c. 1918 image. According to the *Fourteenth Census of the United States Manufactures: 1919: Forest Products,* 2.8 percent of California's lumber industry workers were female. In 1921, twelve million feet of redwood lumber was sawn to become cigar boxes. (HCHS.)

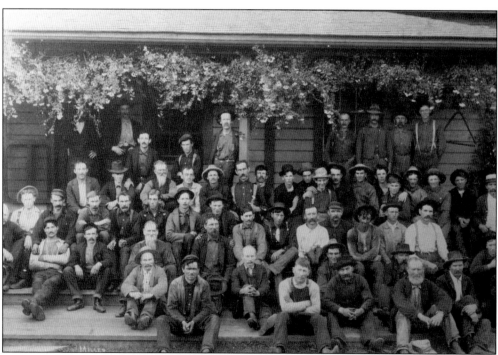

Support of the war effort was found throughout the county. The *Fortuna Advance* reported in June 1917 on a "most enthusiastic and patriotic meeting" at the Newburg mill, noting "nearly every resident and employee of the Eel River Lumber Company responded to a call for a meeting in the interest of the Red Cross work. . . . As a result of these efforts $850 was subscribed for the Red Cross fund." Newburg Mill workers are shown here. (FDM.)

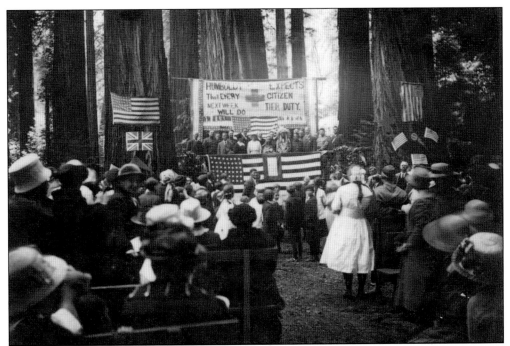

In addition to raising money for the Red Cross fund, Humboldt County citizens also supported the war effort by purchasing war bonds. In October 1917, county residents raised $890,000. Pictured is a Red Cross rally held near Holmes Flat. One of the speakers was Princess Ah-Tra-Ah-Saun (Bertha Thompson), a Yurok actress, photographer's model, and trained nurse, seen at the center of the stage, visible above the vertical banner. (FDM.)

Caught just before landing, Sept. 1, 1919.

New mills also grew from the war effort. Fernwood Lumber Company, 12 miles east of Blue Lake, specialized in cutting Douglas fir for airplane manufacturing. The *Fortuna Advance* explained, "The mill is now cutting some choice lumber for airplanes. The grain of the lumber is soft and uniform and clear, and . . . it commands $65 per thousand" board feet. (HSU.)

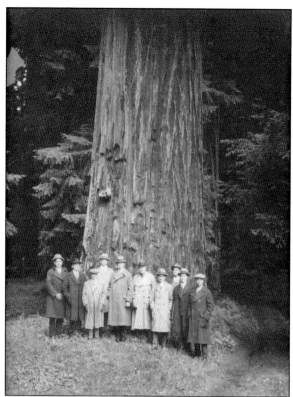

An organization that would have a lasting effect on the redwood lumber industry was created in 1918. The Save the Redwoods League was formed by Madison Grant, James Merriam, and Henry Fairfield Osborn with the goal of preserving redwoods. Concerned by extensive logging of redwood forests along California's coast, they began raising money to purchase and protect the trees. (HRIA.)

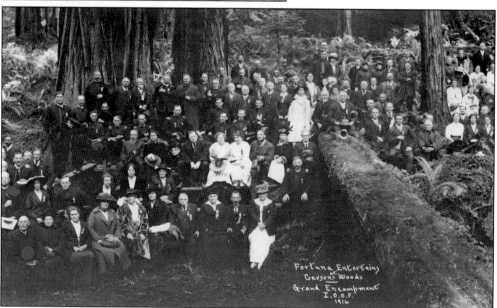

Redwood preservation was embraced by local residents, reported the *Timberman* in July 1915. The magazine noted that "the matter of establishing a redwood park was again being agitated . . . so much of the redwood stand that is easily accessed has been logged off it is the earnest desire of every Humboldter that at least one tract that is in reach of all should be preserved intact." Shown is the Independent Order of Odd Fellows enjoying Carson Woods in 1916. (FDM.)

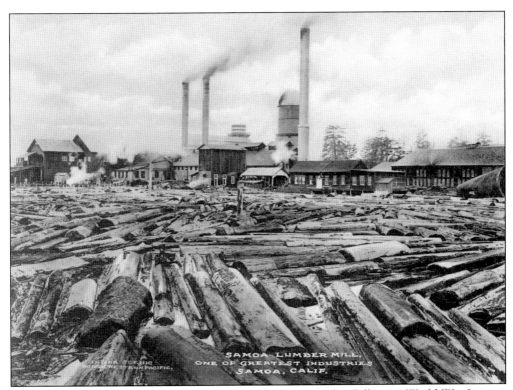

In 1919, Hammond Lumber Company employees went on strike. Following World War I, many industries' workers formed unions, including those in lumber. Hammond Lumber opposed unionization, firing two men for joining the Industrial Workers of the World. The subsequent walkout resulted in "only one bandsaw of the four [at the mill being] able to operate," noted H. Brett Melendy. (FDM.)

Strikers' demands called for reinstatement of all striking employees, including those fired. Mill workers also wanted to be paid time-and-a-half for all work over eight hours a day, including work on Sundays and holidays. Further, they wanted women workers to be paid the same rate as men. The wharf on the bay side of the Hammond Mill in Samoa is shown here. (HCHS.)

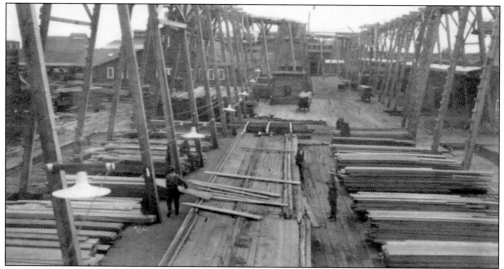

In October, Hammond and 10 other mill owners stated in the *Humboldt Times*, "We . . . do not now favor, and will not in the future, favor the employment of agents or members of that organization [Timberworkers' Union]; . . . we shall do all in our power to protect the rights of, and furnish continuous employment to those loyal employees who are opposed to that organization." Hammond mill's grading table is shown. (UCB.)

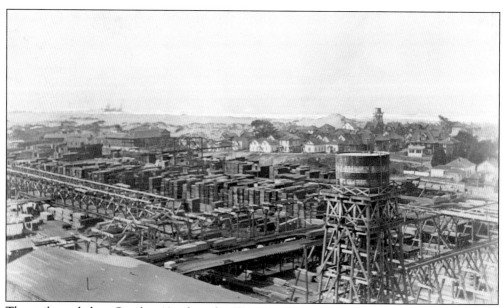

The strike ended on October 10, when the "Superior Court granted a temporary injunction to enjoin the Timberworkers' Union from picketing the mill," according to Melendy. Additionally, county officials "passed an ordinance making it illegal to carry an IWW card." This action by county officials due to the urging of mill owners "brought an end to unionization and strikes for fifteen years." Hammond's mill and company town at Samoa are shown here. (FDM.)

Two

THE ROARING TWENTIES

The 1920s were characterized by the dichotomy between the push from the Save the Redwoods League to preserve groves of redwoods and new technology that allowed trees to be cut at an even faster rate than before. Like the Civil War, World War I resulted in many technological breakthroughs that found their way to the redwood industry. (HRIA.)

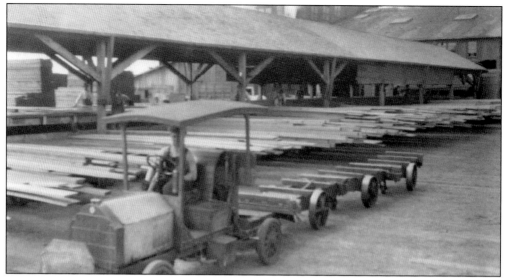

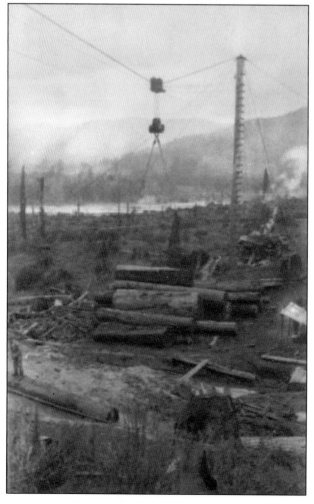

In June 1920, the *Timberman* magazine featured an article, "A Tour of the California Redwood District," describing mill conditions and logging shows. The first mill highlighted was Holmes-Eureka. The *Timberman* reported that J.H. Holmes was having a concrete burner, kiln, and boiler works built. The mill also utilized a "Hood Locomotive" (a Ford truck) to move lumber around the mill, as pictured above. At Holmes-Eureka's woods operations near Carlotta, new equipment included "a 12 X 14 Willamette" (a large steam donkey). The company also operated "a 60-ton Climax and 50-ton Baldwin" connecting woods operations to the mill, 23 miles to the north. Additionally, a donkey locomotive and eight donkey steam engines were in use. Thomas Hine, manager of Holmes-Eureka, developed the overhead cable loader pictured at left. A donkey engine is visible at upper right. (Both, UCB.)

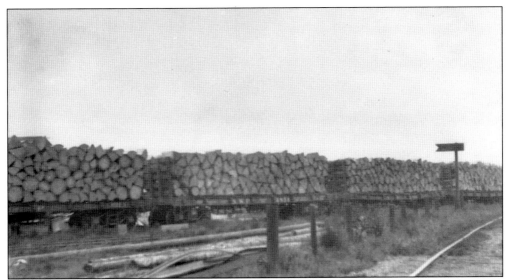

In Arcata, noted the *Timberman*, the California Barrel Company was "manufacturing about 130 cords of bolts daily into staves, headings, and boxes . . . the company also prepares redwood sawdust for grape packing." This picture shows 150 cords of spruce, white fir, hemlock, and Douglas fir used daily by the company. (UCB.)

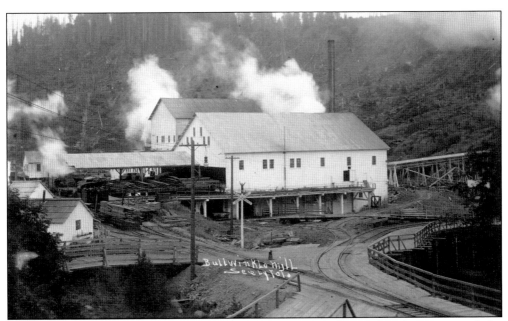

Little River Redwood Company was cutting about 55,000 board feet daily, reported the *Timberman*. The mill had recently installed an automatic sprinkling system for fire prevention. Mill superintendent F.L. Vandusen had applied for a patent for a multiple adjustable ball bearing that could be "applied successfully to any type of machinery, but more especially to fast-running wood working tools." (HCHS.)

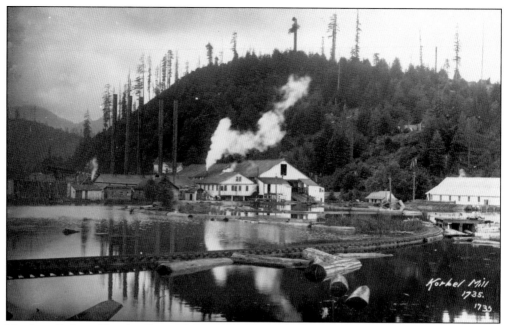

Northern Redwood Lumber Company, according to the *Timberman*, was "operating the Korbel plant on shifts and is cutting 200,000 feet daily. The Riverside plant is cutting 50,000 feet." A monorail was employed for handling lumber, and "the company is manufacturing quantities of Australian door stock in addition to other special material, including cigar box lumber." (HSU.)

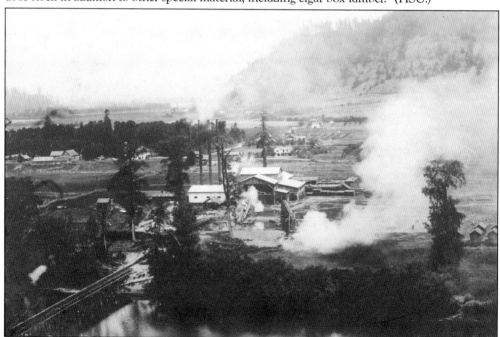

Metropolitan Lumber Company's summer bridge, visible at lower left, was used to access timberlands west of the Eel River and was operational by June 1920, reported the *Timberman*. The magazine noted the mill had "cut about 10 million feet in 1919. Logging operations have gone forward steadily . . . and 28 million feet is felled in the woods." (HSU.)

In 1920, a new mill opened at Carlotta specializing in redwood tanks and pipes. The mill is shown with the Gundlach children in the foreground. Operated by the Pacific Tank Company of San Francisco, the mill used parts from the Bert Robinson shingle mill of Fortuna. The *Timberman* noted the mill would not use a millpond and was equipped with a nine-foot McDonough band mill and a Mershon resaw. (HCHS.)

The *Timberman* observed in 1920 that another new operation, Redwood By-Products Company of San Francisco, was "shipping quantities of redwood bark to Oakland where it was being manufactured into pulp stock. Bark is being handled at the camp of the American Tank Company near Carlotta, with a donkey engine and a high line. The bark is hauled to the railroad with a five-ton White truck by H.E. Baldwin of Carlotta." (UCB.)

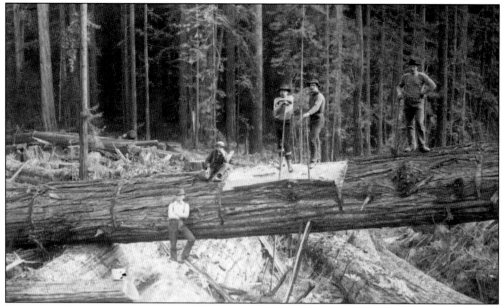

U.S. McMillan, representing Redwood By-Products Company, spoke to the Eureka Businessmen's Association in February 1920. McMillan explained that attempts to make pulp from redwood bark dated to 1906, reported the *Fortuna Advance*. Since 1917, "coarser qualities of paper have been made, and . . . he has shipped more than 500 carloads of redwood bark out of this county." McMillan noted his company planned to build a pulp plant in Arcata. (HSU.)

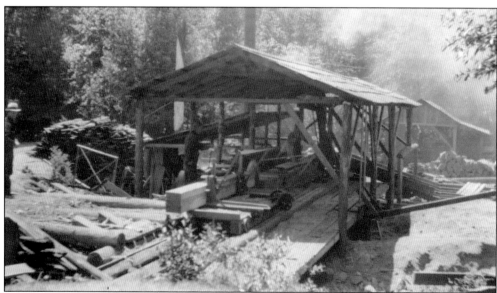

Improvements in machinery during World War I led to the rise of the small lumber operator, such as the Turner and Danielson Mill along Bull Creek pictured here. The two men operated the mill, producing 5,000 board feet a day that they shipped to Oakland by rail. The mill also sawed Douglas fir for fruit boxes. In 1922, new machinery was installed, increasing output. (UCB.)

The railroad allowed for both shipping of lumber and transporting of logs to mills. It also continued to support the split products industry of Southern Humboldt. Shown is a conveyor belt system across the Eel River at McCann used to transport shingle bolts, ties, and grape stakes. (UCB.)

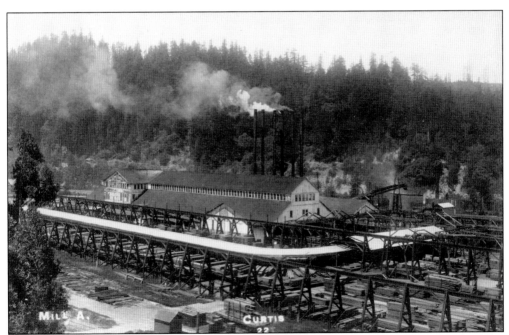

In 1920, TPL Co. was improving its facilities at Scotia, noted the *Timberman*. A modern machine shop had been completed, and a remanufacturing plant was under construction. The company was "producing about 100,000 feet in two eight hour shifts." J.H. Emmert, president of TPL Co., was interested in electrifying the mill. "The saving of fuel, elimination of water supply and freedom from fire hazard" were all reasons for electrification. (FDM.)

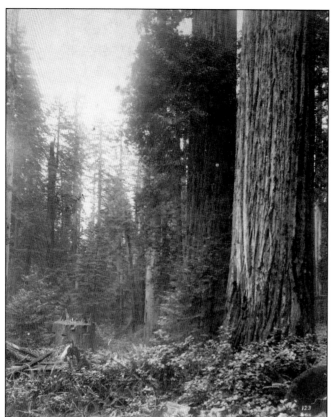

The *Timberman* reported in 1920 that TPL Co. redwood lands along Freshwater creek (pictured) included "about one billion feet of redwood in this tract. A railroad grade built in 1879 . . . is being re-laid and the bridges renewed. About half a mile of additional road will put the line into the timber. . . . At the start, two [sidings] will be operated." (HSU.)

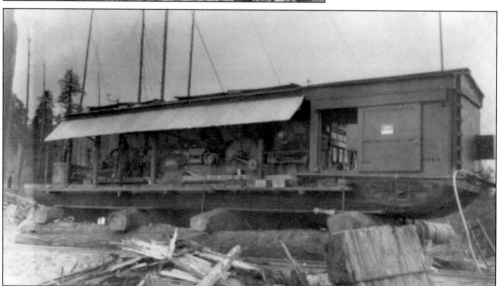

In 1923, TPL Co. purchased a 300-horsepower Willamette electric loader and yarder engine, reported the *Fortuna Advance,* which would "greatly simplify and lessen the expense of handling the big redwood logs in the company's various logging camps in Humboldt. The first donkey with electricity as its motive power is now being assembled at the Pacific Lumber Co.'s Freshwater machine shops." The machine is shown from its loader side. (UCB.)

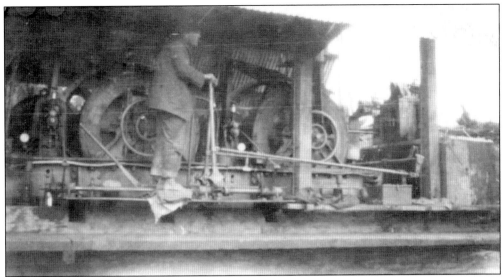

More economical to operate, according to the *Fortuna Advance*, "the saving in fuel and labor alone will pay for the new apparatus." The single operator is shown next to the airplane-type controls of the machine. The engine also provided woods operations "greater flexibility, speed, and freedom from fire danger." Two yarders and loaders of the electric type were purchased, costing "in the neighborhood of $75,000." (UCB.)

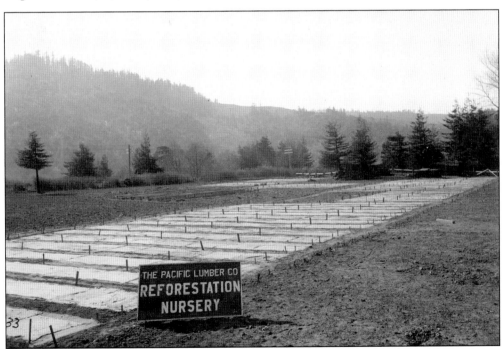

Another innovation embraced by TPL Co. management was reforestation of logged-over lands. The Union Lumber Company, of Fort Bragg, began experimenting with replanting its holdings in 1906, and TPL Co. quickly followed, building a nursery and growing seedlings from seeds locally collected. In 1923, the *Santa Ana Register* reported the "Pacific Lumber Company has a redwood nursery of 500,000 trees at Scotia." (FDM.)

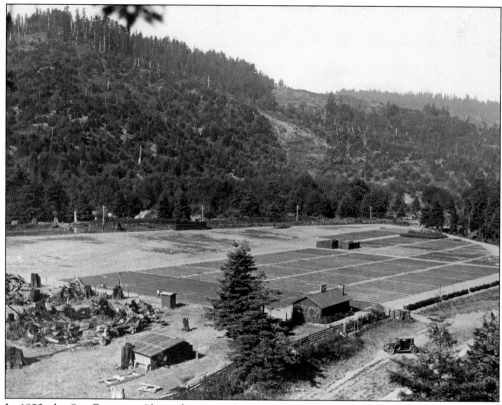

In 1923, the *San Francisco Chronicle* reported, "The California plan of reforestation is said to be the first in the United States wherein practically all the lumber manufacturers of any one region have joined in a serious movement to make their industry permanent." By 1928, a total of 25,000 acres of redwoods had been planted in the redwood region, and over seven million seedlings were planted. (FDM.)

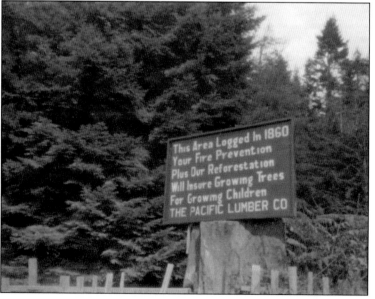

Also in 1923, TPL Co. experimented with logging second-growth redwoods on its lands at Freshwater. The pictured sign explains that the company was logging naturally regrown second-growth timber. Second-growth trees, while not as big or as solid as old growth, soon found a market and would be logged extensively in the latter half of the 20th century. (UCB.)

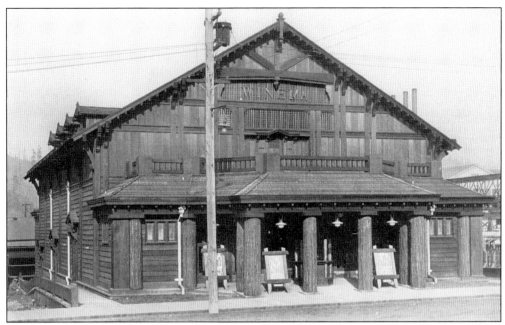

In addition to improving infrastructure, TPL Co. strove to improve employee living conditions. Improvements in 1920 included construction of the Winema Theater. The *Timberman* observed the building had seating for 600 and featured a pipe organ. Built of redwood, with redwood bark–covered columns, it reflects the Craftsman architecture of the era. Starting in 1925, the Winema was the site of the Children's Christmas Party, at which employees' children received holiday presents. (FDM.)

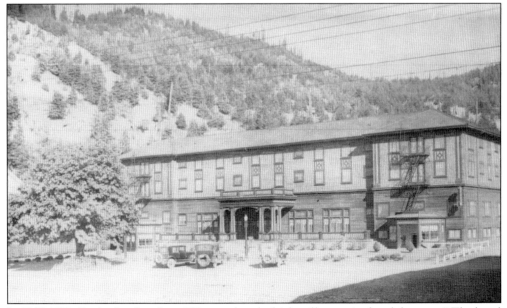

In 1925, TPL Co. built a "modern 150 room hotel which will contain the club rooms." The hotel bar had a double counter, where workers from the mill congregated on one side and owners on the other. The hotel was operated by the company, and many of the rooms were reserved for employees. (FDM.)

In May 1920, the *Fortuna Advance* featured an editorial calling Scotia "an ideal industrial center." Reflecting, perhaps, on the labor strike in 1919, the *Fortuna Advance* observed improvements in Scotia for employees created an atmosphere where "industrial strife and unrest can hardly get a start, let alone thrive. There is no room for the deadly canker dissatisfaction." (FDM.)

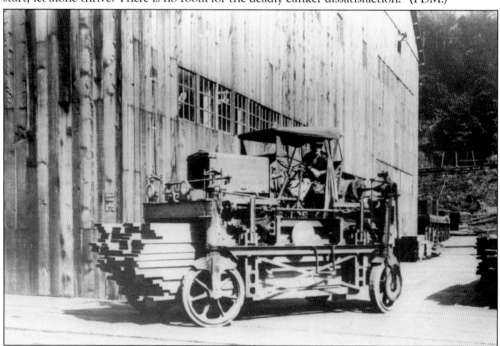

In 1913, Harry Ross, of the Stenson-Ross Machine Works in Seattle, created the "straddle buggy" for carrying lumber around mill yards. As with other technologies, this machine gradually replaced more manual means of lumber transportation. The straddle buggy pictured is at Little River Lumber Company. (HSU.)

Mill work and working in the woods were dangerous. The *Fortuna Advance* reported in 1923 that the Humboldt timber industry accounted "for nearly 40% of the violent deaths during the year." Two years earlier, the *Fortuna Advance* reported TPL Co. log pond employee James Yuill's death. Yuill "drowned . . . when he slipped from a boom, and weighted down by a heavy chain he was carrying, immediately sank to the bottom." (FDM.)

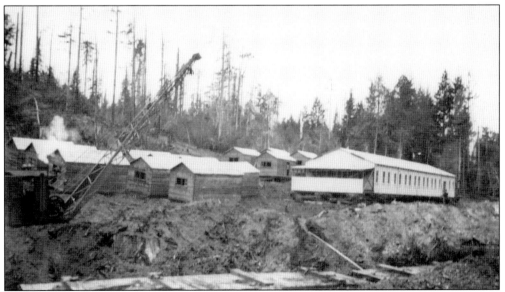

Some accidents were not exactly accidents. In August 1924, George Kerney and Thomas Guyer admitted they dynamited the cabin of foreman Chris Thomson at Hammond Lumber Company's Camp 25. They "gave as their reason that the foreman . . . had incurred their deep dislike on account of his manner in ordering them about in their work." Shown is one of Hammond's lumber camps shortly after being set up in the 1920s. (HSU.)

The 1920s witnessed an extensive search for virgin timberlands to supply county mills. In 1922, for example, Bayside Lumber Company owner Ralph Bull purchased 2,000 acres of redwood timber near Carlotta. The *Fortuna Advance* reported the following January that Bull had "put in a crew of choppers in his new holdings . . . logs will be hauled over the NWPRR to the Bayside Mill." (HSU.)

In 1923, E.J. Dodge Mill purchased 1,600 acres of timberland from M.A. Burns along Howe Creek, west of the Eel River, reported the *Fortuna Advance*. The paper estimated there was "approximately 100,000,000 feet" of timber available, thus supplying the mill with logs for 15 years. Further, "the timber (was) . . . among the best quality to be found in the redwood belt of this county." Shown is the timberland seen from Metropolitan. (UCB.)

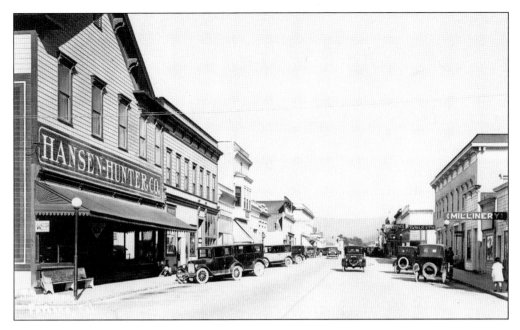

Following World War I, many county residents purchased automobiles, changing how they went to work and creating new challenges for mill owners. In 1925, the *Fortuna Advance* reported that Fortuna's Businessmen's Association was working with Holmes-Eureka to improve access to the company's logging camp along Palmer Creek by extending one of the city's existing streets. Thomas Hine, the company's representative, explained "some thirty of his employees working at the new camp come to their work daily in their autos and it was a difficult matter to get into camp." Conversely, the automobiles allowed employees to work farther from their homes and gave them greater freedom from living in company housing. Additionally, it allowed more people to enjoy the redwood forestland, as the men below are doing on their way to Red Bluff. (Above, HSU; below, HRIA.)

During the 1920s, "high lead" logging was common in woods operations. In *Technical Bulletin No. 283 of the United States Department of Agriculture*, an article by S.B. Show explained the process: "The main lead block is placed on a spar tree up to 200 feet high . . . Several variations of the sky-line method, such as that in which logs are transported by an underslung trolley on a fixed line anchored high above the ground at both ends, are also in use. More recently the caterpillar tractor has been used in yarding." Pictured above is a Hammond landing where the high lead pole is used with a "gin" pole for loading. At left, a climber or rigger is climbing the spar tree to repair a break in the cable at the Dolbeer and Carson woods operations. (Both, UCB.)

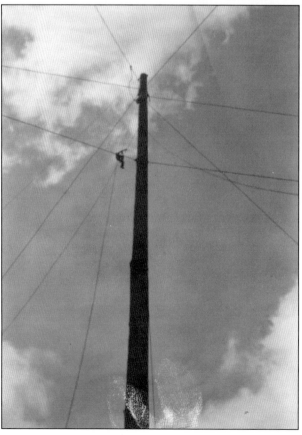

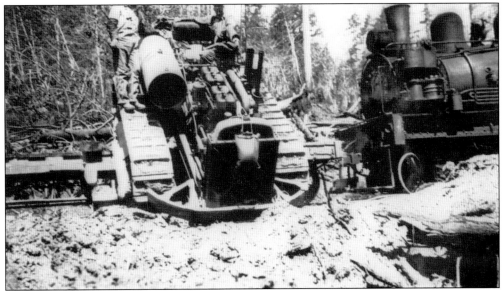

Tractor crawlers, known as "cats," another innovation growing out of World War I technologies, began to be used in woods operations in the 1920s. The Holt Manufacturing Company advertised their 10-ton caterpillar tractor for skidding and log hauling in the *Timberman*. Holt's 1920 advertisement claimed "a crew of 9 men with a 10-ton caterpillar tractor can fell, limb and skid within one-half mile radius, 20,000 feet per day for $4.00 per thousand. The 10-ton artillery model is built narrow and with great clearance." Shown above is an early model cat being unloaded in the Hammond woods. By using "cats," explained S.B. Show, "logging costs can be reduced materially." Below, a cat is pulling an arch in the Dolbeer and Carson woods. (Above, HSU; below, UCB.)

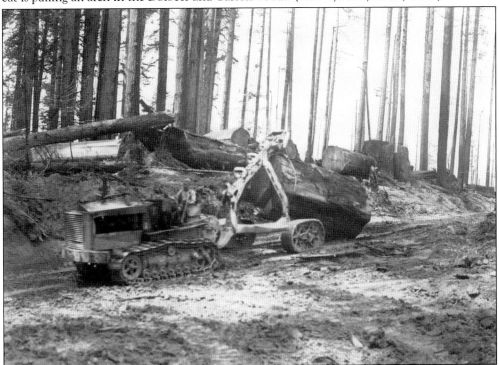

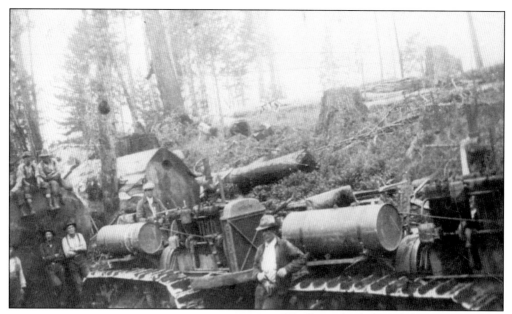

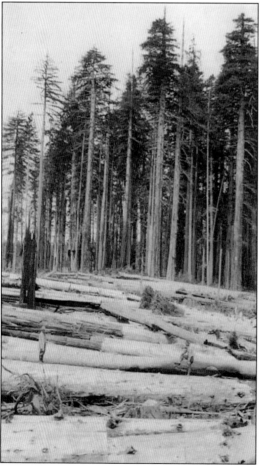

S.B. Show also believed that caterpillars reduced the need for burning off the logging show before bringing logs to mills. He noted that timber was "felled usually months, and often a year or more, in advance of yarding . . . after falling and limbing are completed, most companies peel the logs and then fire the enormous accumulations of bark, limbs, and tops while the logs are still on the ground. This practice results in serious loss of merchantable material, for much of the sapwood and big chunks of shattered but merchantable logs are burned." Shown above is a cat in the Hammond woods, and logs left in woods prior to a fire to remove debris at left. (Above, HSU; left, UCB.)

Fire was an omnipresent threat to both mills and woods operations. The *Timberman* in 1914 suggested that forbidding smoking in the woods might curb wild fires. W.W. Peed, superintendent of logging for Hammond Lumber Company, was opposed, noting "at least half a dozen [fires] have resulted from our operation and the biggest portion of the time from carelessness." To help suppress fires, Hammond Lumber Company installed on a railroad flatcar the water tank car with an Evinrude motor, pump, and hose pictured above. It could be taken quickly to the woods but would have been ineffectual on fires far from the line. The photograph below of a fire in the Hammond woods in 1920 was taken by Emanuel Fritz. Fritz noted, "Fire was burning in area that had not been previously burned and where logs were ready for yarding." (Both, UCB.)

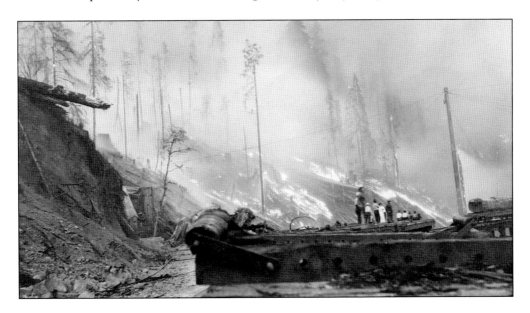

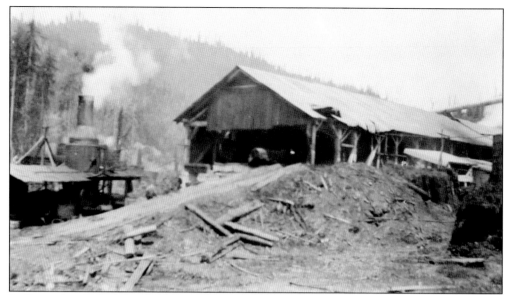

In September 1923, large fires raged south of Scotia, near Brown's mill. The *Fortuna Advance* reported "a forest fire has been raging in the woods surrounding the mill. For a time, the mill was threatened and considerable lumber was burned. Trees also fell across the highway . . . Damage by fire to the amount of several thousand dollars was suffered by Mr. Brown." (UCB.)

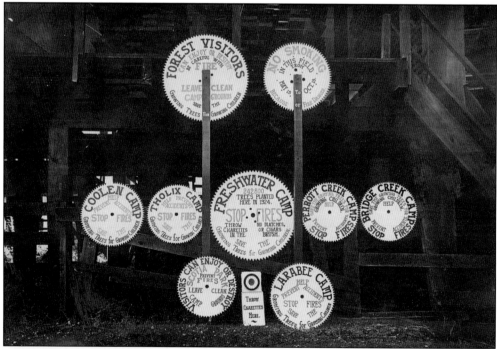

In 1925, TPL Co. had these signs made from old saws to post in their camps, reminding employees and visitors to be fire safe and protect the forests. Many signs carry the admonition "save the growing trees for growing children." This phrase was part of TPL Co.'s promotion of the redwood industry as both the creator of a needed product and a steward of the land for future generations. (UCB.)

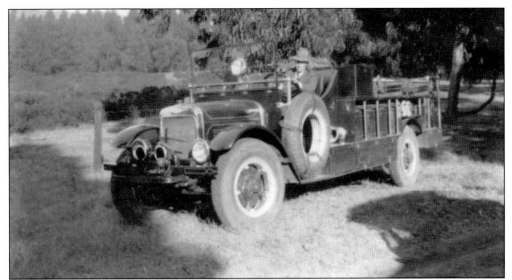

In response to wildland fires, California governor Clement Young organized a state Department of Natural Resources, with a Division of Forestry and a Division of Beaches and Parks in 1927. Although responsible for forestry practices and wildland fire suppression, the Division of Forestry did not allocate trucks or crews to the North Coast until the 1930s. Pictured is State Fire Truck No. 4, assigned to Ukiah, during fire prevention week in Berkeley Hills in 1929. (UCB.)

The use of trucks in woods and mill operations increased dramatically after World War I. These first trucks were only able to haul finished redwood products, such as split products and shingle bolts. The split products industry embraced the trucks and began using them extensively. (HSU.)

In July 1920, the *Timberman* printed a "list of California Truck Owners." Included are local lumbermen and their trucks as follows: "George Matthews, Dyerville, is employing a 3 1/2 ton Acason Truck as is also William Turner of Dyerville, in transporting grape stakes and split stock. B. Gianoni and Angelo Bassl, Holmes, are hauling ties, posts, and tan bark with a 3 1/2 ton Clydesdale truck." (HSU.)

The *Fortuna Advance* in March 1921 reported "heavy trucking between Englewood and Dyerville . . . has resulted in unsatisfactory traffic conditions on the highway. . . . Since the comparative good weather of the past three weeks there has been an unusual amount of hauling over the road with the result it is badly cut up." (HSU.)

Truck use increased with the completion of the Redwood Highway to the Oregon border in 1922. Conversely, damage done to redwoods by construction was one factor stimulating the formation of the Save the Redwoods League (SRL). In 1920, SRL purchased its first grove, dedicating it in 1921 to Col. Raynal C. Bolling, the first high-ranking US officer killed in World War I. Bolling's father donated the money for the grove, believing it a fitting memorial for his son. The *San Bernardino Daily Sun* noted in 1921 a redwood grove memorial would "grow in grandeur from year to year, while monuments of stone will disappear and that which they commemorate be forgotten." (Both, HRIA.)

SRL successfully raised money for redwood preservation. The Stephens, Mather, and Kent Groves were added to what became known as the Humboldt Redwoods in 1922. Groves were purchased at fair market value from lumber companies. By 1923, the stretch of highway through the forests in southern Humboldt was known as the Avenue of the Giants. In 1927, these groves gained further protection, becoming part of the newly formed Division of Parks and Beaches. (HRIA.)

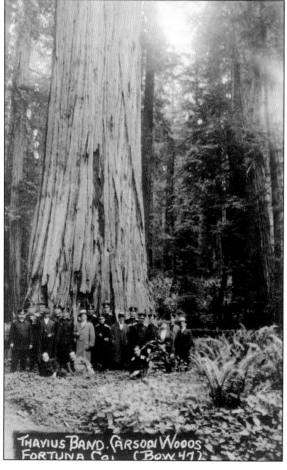

THAVIUS BAND. CARSON WOODS FORTUNA CO. (BOW. 47)

Despite local support for preserving redwoods, some groves considered for a park were logged. In 1922, Holmes-Eureka initiated plans to log Carson Woods, to the north of Fortuna, which it had recently purchased, to the dismay of SRL members and locals alike. The *Fortuna Advance* reported in October 1922 that "choppers will probably be turned loose on this magnificent grove within the next few months." (HSU.)

The *Fortuna Advance* stated, "Carson Woods with its century old giants are doomed. . . . Carson is a name that stands among the best loved and honored men of our own pioneers. It is to be regretted that . . . Carson Woods which should have perpetuated the memory of a grand old gentleman will in a few short months be a hideous sight of charred stumps—revolting to the lover of nature." (HSU.)

Preservation and harvesting of redwoods continued to be juxtaposed throughout the 20th century. While the Save the Redwoods League worked to preserve trees, H. Brett Melendy noted, "During 1929 the mills [of Humboldt] all operated the full year and had many orders yet to fill at the end of the season." (Library of Congress.)

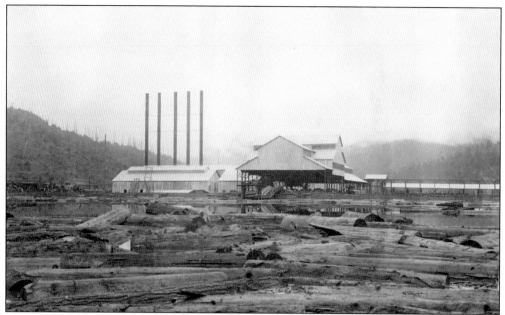

A debarking plant was installed in 1929 at TPL Co.'s mill. Replacing peelers manually removing bark, the debarker also meant less debris in the woods. Further, it allowed for new products created from bark. Bark was sold as an insulation material. The third school at Rio Dell, for example, used bark insulation, as the bark was fire and insect resistant. (FDM.)

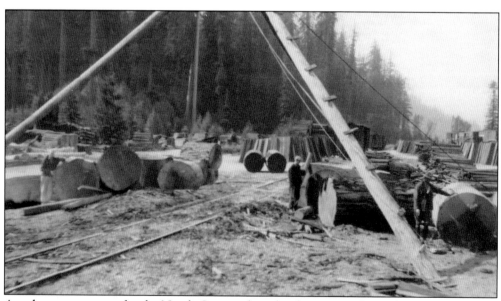

Another new concept for the North Coast redwood industry was plywood. In 1928, redwood veneer bolts, short high-quality logs, were shipped from South Fork (shown) to a plywood mill in Martinez. The California Barrel Company in Arcata began producing veneer for use in making containers in 1929. The Great Depression stopped experimentation with plywood, but it would resume in the 1950s when many plywood mills came into existence. (UCB.)

Three

THE GREAT DEPRESSION AND WORLD WAR II

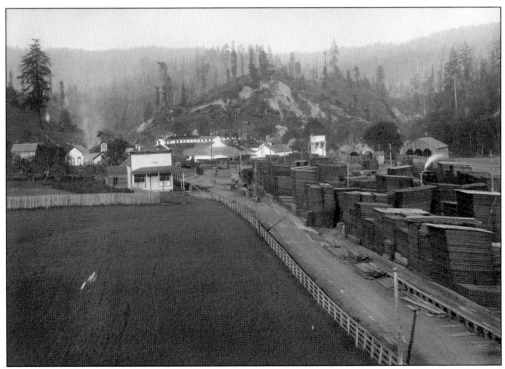

The 1929 stock market crash and ensuing economic depression severely affected the redwood lumber industry. Many mills closed, some never to reopen, including Eel River Valley Lumber Company, pictured here. During this time, violent strikes broke out in Pacific Coast lumber mills, with deadly results in Eureka. The 1930s were a period of transition in woods and mills technology, and diversification in lumber products. (Clarke.)

In 1931, A.S. Murphy, grandson of Simon Murphy, who had gained control of the company in 1905, became TPL Co.'s president. Murphy faced great challenges when he took the reins of the company. Local mills had been forced to shut down, laying off employees and selling off their properties as the economic slump meant no markets for lumber. (FDM.)

Murphy was instrumental in the survival of the company through diversification and adaptation of new technology and logging practices. For example, under his auspices the company built and installed a Pres-to-log mill. The mill utilized sawdust and other wood by-products to make a small log to burn in fireplaces. (HCHS.)

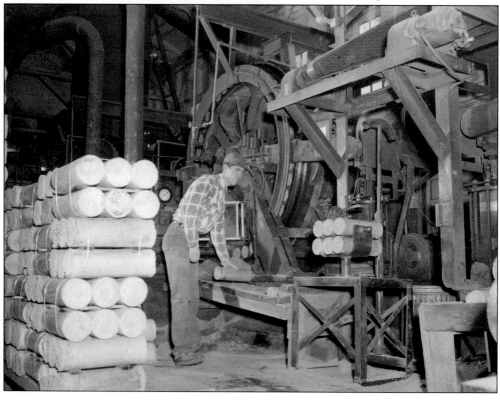

The Pres-to-log was invented in Potlatch, Idaho, in 1930 with the goal of utilizing sawdust. The created logs provided even heat, were easy to use, and did not require chopping. An article for the Potlatch Corporation's newsletter in 1937 noted Pres-to-logs "produced no dirt, no smoke, no soot, no odor, and no ash." TPL Co. eventually had four machines churning out 20 tons of "logs" a day. (HCHS.)

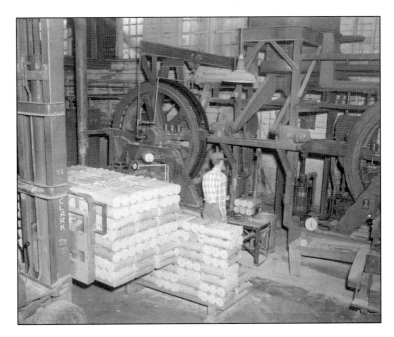

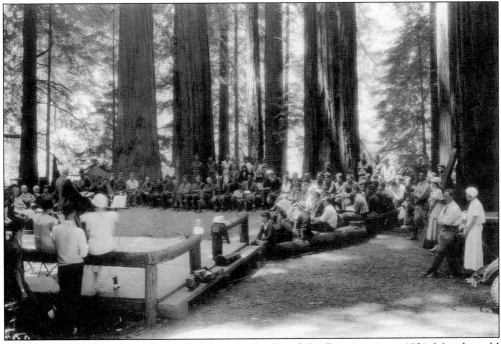

Further enabling TPL Co. to weather the vicissitudes of the Depression, in 1931, Murphy sold 10,000 acres of virgin redwood timber to Save the Redwoods League. This timberland became known as Rockefeller Forest, now the largest stand of old-growth redwood left in the world. The sale put $3 million into TPL Co.'s coffers and helped to preserve redwoods for future generations. (HRIA.)

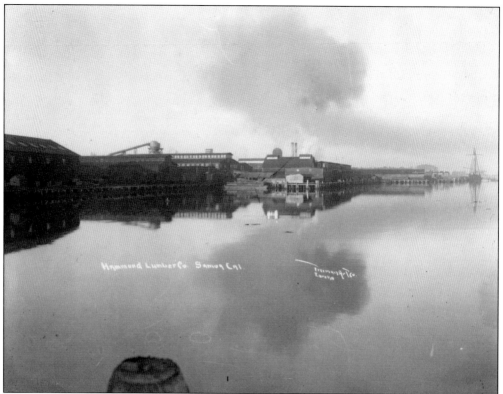

Similarly, Hammond Lumber Company and Dolbeer and Carson survived the Depression, although their business was curtailed. Like TPL Co., Hammond Lumber experimented with other products, including plywood manufacturing. During the 1930s, Hammond Lumber Company shipped bolts to Gray's Harbor to experiment with making veneer. This experimentation was stopped by the start of World War II, with all efforts being redirected for the war effort. (HCHS.)

By 1931, only Hammond Lumber Company, Dolbeer and Carson (pictured), and TPL Co. were operating. No mills were running in Del Norte County, and only Fort Bragg's Union Lumber Company operated in Mendocino County. Melendy notes that while the companies were able to survive, "There was considerable hardship among the workers, many of whom were laid off." (HCHS.)

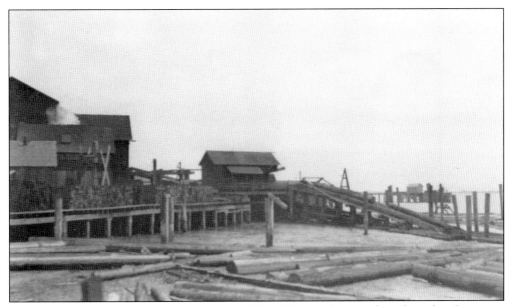

The hardest years for the local economy were 1931–1933. Northern Redwood Lumber Company, Occidental Mill, and E.J. Dodge Company all closed. Humboldt Redwood Company closed in 1931 after sawing what was in its lumber pond, so it would not be destroyed by teredo, a sea insect that bores through wood. Holmes-Eureka, shown here, followed a similar tactic. (UCB.)

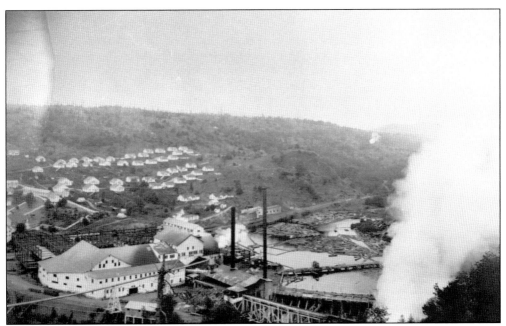

Another survival strategy was merging companies. In 1931, Little River Redwood Company merged with Hammond Lumber Company, bringing Hammond control of 10 billion feet of timber. While not a buyout, Melendy notes that "Hammond interests were dominant." In July 1931, the Crannell mill closed, affecting 500 men. The mill kept married men employed, but 200 others lost their jobs. Those who remained employed took a 10 percent cut in wages. (HSU.)

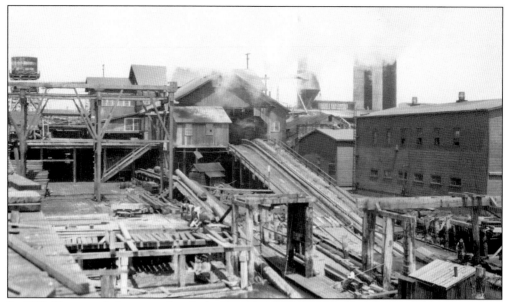

In 1932, Hammond also merged with the Bayside Mill, but in April 1933, the Hammond mill at Samoa, pictured here, shut down for the remainder of the year. The *Press Democrat* of Santa Rosa noted, "several hundred men were affected. During the past several weeks shut-downs have been made in the logging woods of the company . . . The total number of men laid off in the woods and the mills is close to 1000." (HCHS.)

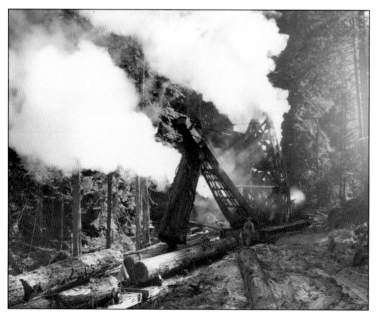

Yet by the fall of 1933, signs of improvements could be found in the redwood region. Some mills resumed operations, in accordance with the recommendations of the National Recovery Administration (NRA). The *Press Democrat* reported in October 1933 that TPL Co. was "working over 600 employees in the mill and in the woods camps." TPL Co. woods operations are seen here. (FDM.)

The National Recovery Administration was created by Pres. Franklin Roosevelt in 1933 to help stimulate the economy. The NRA's goals were to eliminate unfair labor practices, reduce unemployment, and establish minimum wages and maximum hours. To that end, reported the *Press Democrat*, mill owners paid "minimum wage scales of 35¢ an hour," the "majority of the scales being above this figure." (FDM.)

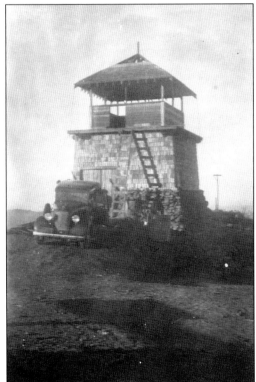

Another of Roosevelt's Depression-era plans was creating the Civilian Conservation Corps (CCC). Ten camps were established in Humboldt County, one at Dyerville. TPL Co. donated land used by the camp. The company in turn benefited when the CCC built a forestry fire lookout, shown here, on top of Grasshopper Peak in the Bull Creek drainage. This helped to protect much of TPL Co.'s timberlands. (HRIA.)

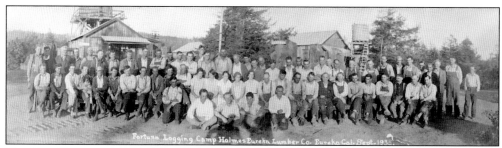

The *Press Democrat* reported that although the lumber industry had been at a standstill, "with only skeleton crews operating and very little, if any, wood camps activity, increased orders for California redwood lumber from all parts of the country and adoption of the lumberman's code has again aroused activity." Even so, recovery was slow to come to Northern California. Holmes-Eureka woods crew members near Fortuna are pictured in 1933. (HCHS.)

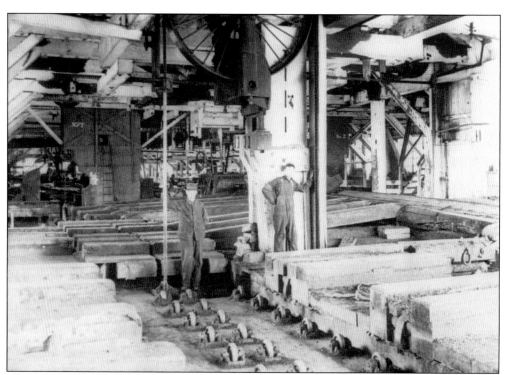

When A.B. Hammond died in 1934, the company continued operations under a board of directors. One of Hammond's legacies was changing mill owners' perception of employees from assets and individuals to being "an overhead cost of production, that could be ratcheted up or down as the situation demanded," Greg Gordon explains in *When Money Grew on Trees*. Two Hammond employees at the Samoa mill are pictured. (HSU.)

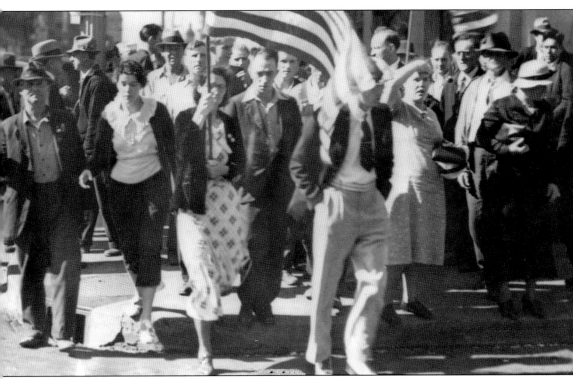

In 1935, there were strikes throughout the United States amongst longshoremen, coal workers, and lumber workers. The Pacific Coast lumber strike stretched from Humboldt County to Bellingham, Washington. Protestors in Tacoma, Washington, are seen here. Strikers sought a pay raise—to 75¢ an hour—shorter hours, and recognition of unions. Locally, the strike call by the National Lumber Worker's Union received little support. According to the May 21, 1935, *Seattle Post Intelligencer*, "Although the timber and sawmill workers' union called for a strike to include the 3500 men employed in the timber industry in Humboldt County, Calif., only 300 men walked out, and of those, 150 of these later went back to work." For many Humboldt mill workers, fear of losing their jobs outweighed possible gains of higher wages and shorter hours. Further, although not as high an increase as the union asked, on May 1 Humboldt mill owners voluntarily voted to increase wages by 10 percent. The *Ukiah Republican Press* speculated that owners aimed to "avert a strike which it is feared, would tie up all mills of the northwest." (FDM.)

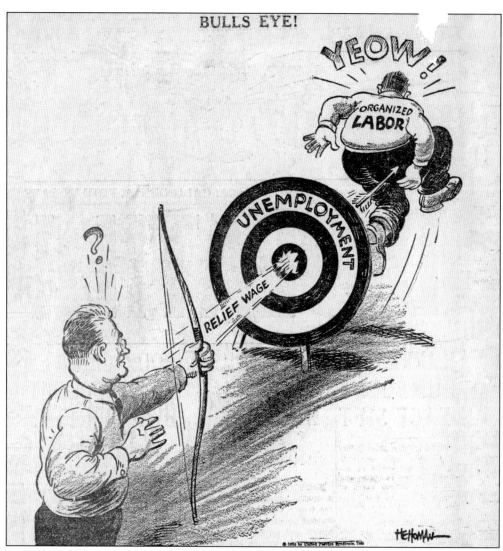

In April 1935, Abe Muir, union organizer for the Northwest Council of Lumber and Sawmill workers, spoke to local union members. His message: request a raise to 75¢ an hour, a 48-hour work week and immediate union recognition, and strike if demands are not met. On May 11, 1935, union members voted to strike if mill owners refused to meet with union negotiators. Although union strikers were in the minority, they were very vocal, creating a confrontational environment. Picketers protested both at mills and in woods operations. In mid-May, the *Humboldt Standard* reported, "Pickets move activity into logging areas." The newspaper also added that according to the owners of the five mills operating in the county at the time, "94.6 of all employees at work on May 1 were at their jobs, either in mills or camps." One hundred percent of Dolbeer and Carson and 95 percent of the Pacific Lumber and Hammond employees all declined to strike. Positions left open by strikers were filled by companies with men on a waiting list. This editorial cartoon was printed in the *Humboldt Standard* on May 31, 1935. (FDM.)

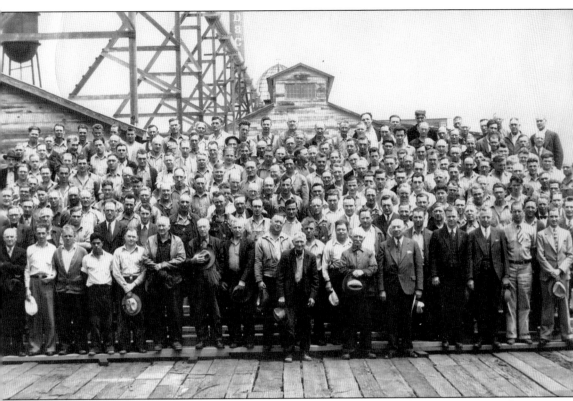

To demonstrate their support of mills and owners, employees of Dolbeer and Carson, Hammond, Little River, Holmes-Eureka, Arcata Barrel, and TPL Co. signed petitions pledging their endorsement of their employers. The Dolbeer and Carson pledge, printed in the *Humboldt Standard*, states: "We, the undersigned employees of the Dolbeer and Carson Lumber Company, [employed for] from one to fifty years, take this method of informing our employers of the following facts: 1) We have always received the greatest consideration from our president and friend Mr. J.M. Carson, and do not need a union or any other organization to make demands for us. 2) We are fairly treated and have no complaints or grievances." Additionally, a note from Carson was printed, stating, "This list of names was unsolicited by me and represents 100 per cent of the Bay Mill employees. None of the head men . . . or myself knew anything about it until the list was presented this morning." Dolbeer and Carson workers were photographed when they submitted their pledge to J.M. Carson (first row, far right). (HCHS.)

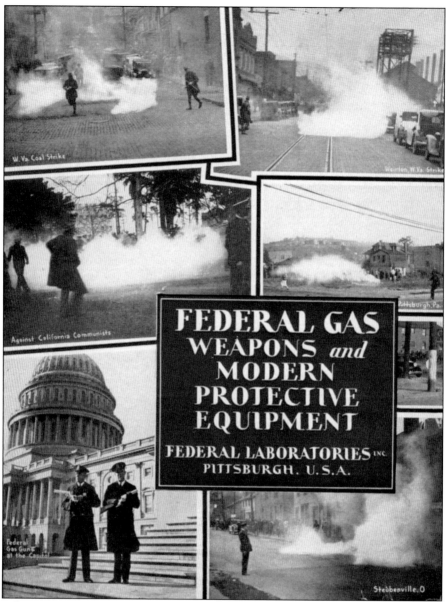

Law enforcement agencies as well as mill owners were concerned about increasing tensions in Eureka, as reports filtered in about violent protests in Seattle and Tacoma. A local incident occurred on June 8 when union members gathered at the foot of F Street (where the *Antelope*, one of Hammond's ferries, docked) to urge Hammond employees to join in the strike. While there were several scuffles, no one was seriously injured. One beneficiary of the unrest was Federal Laboratories, of Pittsburgh, Pennsylvania, a manufacturer of tear gas, noted Frank Onstine in *The Great Lumber Strike of Humboldt County 1935*. A Federal Laboratories salesman came to Eureka during June, and "Hammond Lumber Company added to its arsenal $1,272 worth of tear gas and equipment." Local police also made purchases. Mayor Sweasey of Eureka proclaimed in the *Humboldt Standard* that "protection would be given every worker who wanted to continue on his job, while strikers would receive full protection, as long as they maintained law and order." (Harold J. Ruttenberg Papers, 1934–1998, AIS.1999.04, Archives Service Center, University of Pittsburgh.)

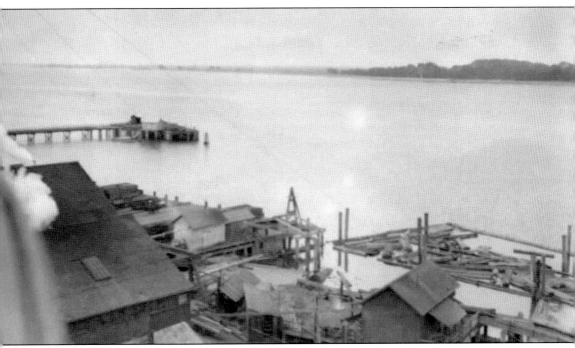

With the lack of support from timber workers, the strike began to falter. The *Petaluma Argus-Courier* observed, "Efforts of strike organizers [have been] thus far virtually unnoticed in the Eureka industry." In a final effort to make a difference, union members met on the evening of June 20, deciding to focus their energies on one mill, randomly selected, "in an effort to shut it down completely." Early on the morning of June 21, Frank Onstine writes in *The Great Lumber Strike of Humboldt County 1935*, "the order was given for pickets to assemble at the Holmes-Eureka Gate." Holmes-Eureka was one of the mills that shut down in 1930, reopening only to mill the logs in its millpond and then closing again. The mill had restarted in 1933 after being closed 28 months, the *Press Democrat* observing "more than fifty family men will go back to work." The company slowly increased its labor force as markets began to improve in 1934 and 1935. Thirty percent of the Holmes-Eureka workforce had voted to strike. (UCB.)

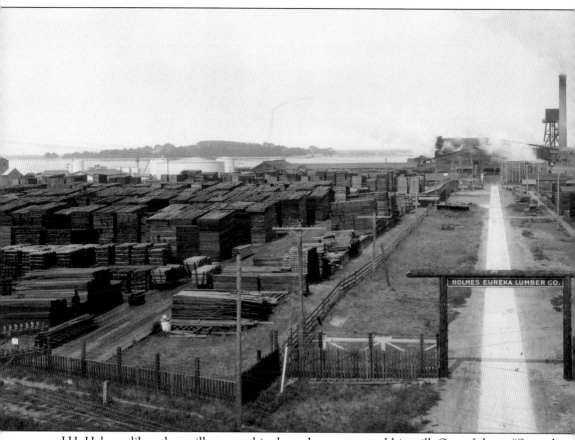

HOLMES EUREKA LUMBER CO.

J.H. Holmes, like other mill owners, hired watchmen to patrol his mill. One of them, "Special Officer" Forrest Horrel, observed picketers arriving at 6:00 a.m. The picketers began to prevent Holmes-Eureka employees from entering the mill and blocked the highway. According to the *Oakland Tribune*, Eureka police believed some picketers were " 'transported' into the northern California lumber regions from the northwest in an effort to precipitate a strike in sympathy with the walk out of Washington and Oregon lumber workers." The *San Mateo Times* reported picketers stopped a car driven by James O'Neil, another watchman, who after eluding picketers, drove into Eureka, alerting police. As police arrived, they were "greeted with jeers and barrage of rocks and other missiles." The *Humboldt Times* reported that when Chief George Littlefield arrived on the scene, picketers stopped his car. Littlefield climbed out, pistol in hand, saying "Who's going to stop me?" Littlefield was followed by a Packard containing police captain Rutledge and several other officers. Shortly after Littlefield's remark, an officer in the Packard threw a tear gas canister into the crowd. (HCHS.)

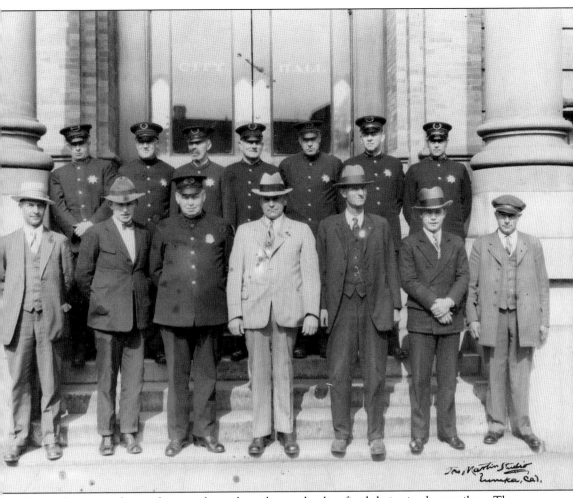

During the riot, picketers threw rocks at the police and police fired their pistols at strikers. The *San Mateo Times* reported, "Fighting became furious. Police fired tear gas, then opened fire with their revolvers." The "salvo of police bullets and tear gas terminated the melee, which left one man dead, nine injured or wounded." At one point before the riot was controlled, picketers disarmed Littlefield and beat him unconscious with his own billy club. Once order was restored, numerous casualties were found on both sides, including Chief Littlefield. Many were treated at home, fearing arrest if they went to the hospital. One striker, Wilhelm Kaarte, a 62-year-old woods crew cook, was killed outright, shot in the throat. Two others, Paul Lampella and Harold Edlund, were severely wounded and later succumbed to their injuries. Over 100 picketers were arrested and taken to jail. Police officers injured in the melee were Pete Carroll (first row, second from left), traffic officer Bill French (first row, far right), Capt. Tom Rutledge (second row, far left) and Chief George Littlefield (second row, third from right). (HCHS.)

For Humboldt, the strike was over, although it continued in Oregon and Washington. The demand for increased wages was met over the next 14 months, with companies raising wages several times. The *Press Democrat* reported in June 1936 that Hammond and Little River, TPL Co., and Elk River Company all increased wages from 5 to 10 percent, as had Dolbeer and Carson. Companies could institute wage hikes because lumber demand was higher in 1935, with more timber cut than in any year since 1930. However, the *Press Democrat* noted that the value of the 380 million board feet sawn in the entire redwood belt was about half of that cut in 1927. Above, in 1935, Hammond woods crew members are, from left to right, Alex ?, Henry Myers, Ed Erickson, and George Lennon. Lennon is also pictured below, at center, in this image of a "slacker" engine. (Both, HSU.)

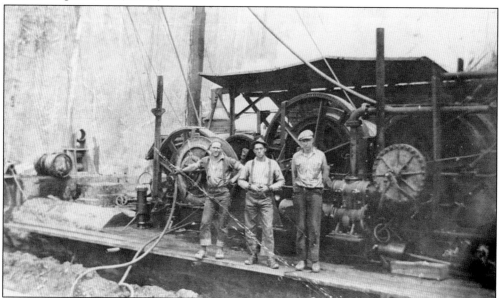

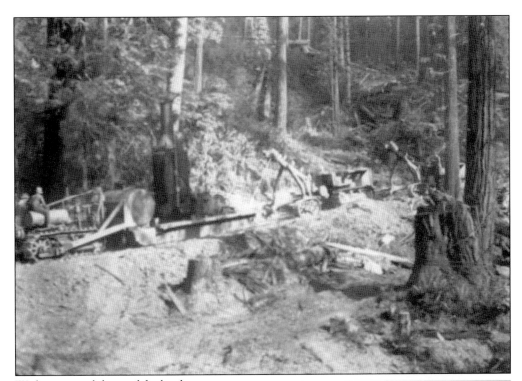

With increased demand for lumber, machines expediting the process were sought. In August 1935, the *Ukiah Dispatch Democrat* noted previous logging techniques "were expensive and when the logs were dragged they destroyed most of the young growth of trees and left the logged over section looking like a desert," while dozers eliminated some of this destruction. The *Ukiah Dispatch Democrat* noted, "Diesel caterpillar engines can climb a hill with an angle of forty-five degrees, pick up big logs and carry them where desired." Caterpillar dozers had 75 horsepower, running on crude oil, costing about 6¢ a gallon to operate. Dozers also pulled large arches hoisting redwood logs off the forest floor. Shown at right is a Cletrac tractor in the Dolbeer and Carson woods operations and two cats moving a steam donkey in the Holmes-Eureka woods, above. (Both, UCB.)

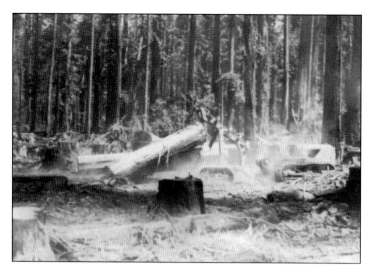

In 1936, Hammond Lumber Company logged with dozers along the Van Duzen (pictured), marking the company's first large scale logging plan with dozers, although Hammond crews had used cats since 1928, according to Melendy. With the machine's use, new words entered the loggers' lexicon. Operators of cats were called "cat-skinners." (UCB.)

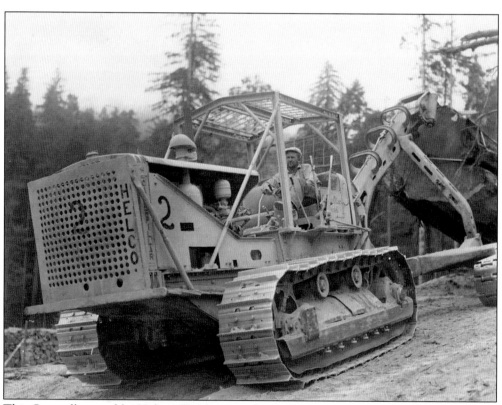

This Caterpillar, used by Holmes-Eureka at its Camp Bemis operation along the Van Duzen, reveals the ingenuity that was part of woods operations. The cat was modified by the crew to provide the driver some modicum of safety using 35-pound railroad iron to make the roll-over cage. Further, the blade and trunnions were removed; in this form, it was called a swing machine, used only for skidding logs. (UCB.)

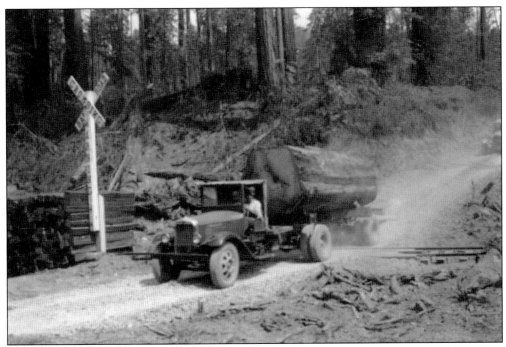

One slow technological transition in woods operations was the use of trucks to haul logs from woods to mills. Logging trucks were first used to connect woods operations to rail lines, as shown in the 1935 image above of a log being delivered from Hammond's Carlotta logging operations to the railhead. Truck roads were cheaper to build than extending railroads. Additionally, truck technology was improving, allowing trucks to haul heavier loads. In a history of the White Motor Company for *Motor Trend* magazine, Bill Senefsky notes, "White's first six-cylinder platform, the 3-ton Model 59, appeared in 1928; 10-ton, three-axle versions followed in 1930." The logging truck below at Hammond's Carlotta woods operations features an adjustable dolly on the trailer, allowing it to be lengthened to accommodate longer logs. (Both, UCB.)

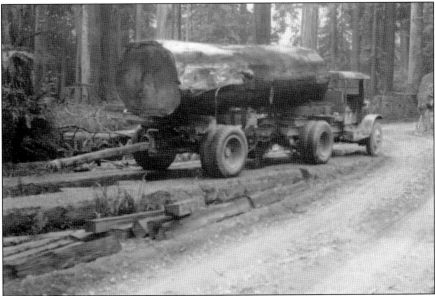

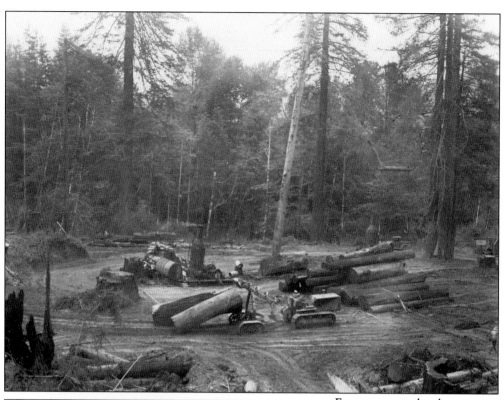

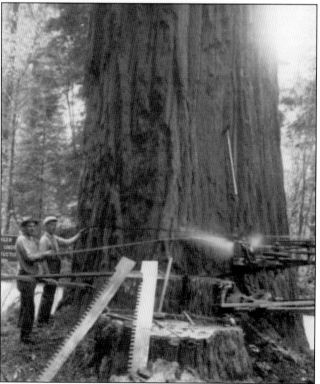

Even as new technology was brought into the woods, old technology continued to be utilized, as shown here. A steam donkey has been adapted to load logs at a landing onto a truck. With the economic pressures of the 1930s, companies often found ways to reuse older machinery. (UCB.)

Dragsaws, like trucks, slowly became more usable in woods operations as the technology improved. Finding a way to replace the misery whip with a machine and expedite the logging process was of great interest to mill owners. Dragsaws of the 1930s were bulky and heavy, yet they greatly reduced the time required to log a redwood tree. These versions weighed around 250 pounds, so were not as portable as claimed. (UCB.)

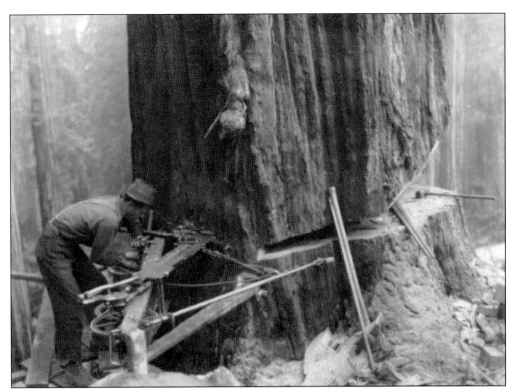

Innovation and experimentation led to mounting dragsaws sideways, with extra scaffolding for support, enabling the "Humboldt" cut. The dragsaw allowed an undercut to be made in denser "butt" wood, thus increasing the amount of wood sent to the mill. The undercut appears upside down, allowing the base of the redwood to slide off the stump, also limiting the breakage the tree was prone to. In the late 1930s, chainsaws were invented in Germany by Emil Lerp and Andreas Stihl. However, it would not be until after World War II that chainsaws would become commonly used in the redwood forest. Emanuel Fritz noted on the undercut image that the cut was made by a gas dragsaw in 1935 on a 290-foot tree, with a diameter of 11 feet near its base, near Stafford. (Both, UCB.)

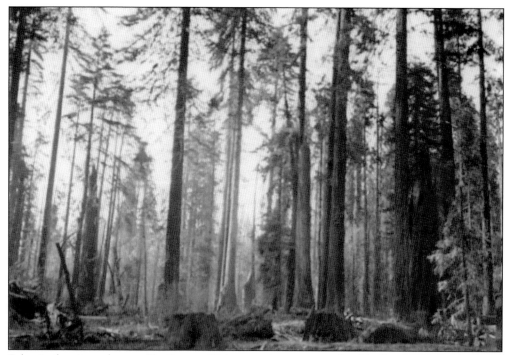

Selective logging, advocated by Emanuel Fritz, creating a sustained yield of lumber, was introduced to woods operations in the mid-1930s as a way to ensure a future for the timber industry. In a 1938 article in the *Bakersfield Californian*, Fritz explained "a redwood can speed up its rate of growth from far less than 1 percent per year at the time of cutting competing trees, to over 5 percent when the competitors are removed." Further, "with conscious effort to leave a sufficient number of immature trees, and to protect against damage, it is possible to get enough timber in 20–25 years after the first cutting of merchantable timber to warrant re-logging. It is possible then to get from 20,000 to 45,000 feet per acre." An Allis-Chalmers Diesel 80 tractor and arch are shown below in Hammond Lumber Company's selective logging in 1935. (Both, UCB.)

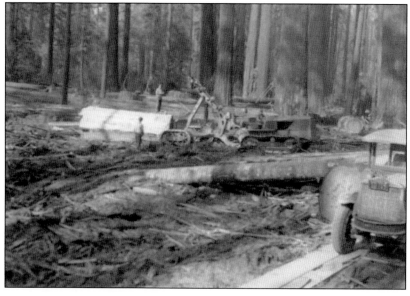

Fritz was instrumental in creating the annual Redwood Region Logging Conference. He used these gatherings as a forum to explain about sustainable harvesting as well as to encourage more environmentally sound practices. At the 1936 conference, he discussed how to log with a cat and arch. He also advocated fire safety, discouraging burning slash after logging. (HSU.)

In 1937, the National Forestry Conference recognized the redwood lumber industry as "leading the nation in scientific methods," reported the *Bakersfield Californian*. Emanuel Fritz observed "the lumber industry is making substantial progress in . . . selective logging, whereby the timberlands are left in a condition favorable to regrowth . . . remov[ing] every threat of a shortage of timber." The logging operations of TPL Co. along Monument Creek are shown. (UCB.)

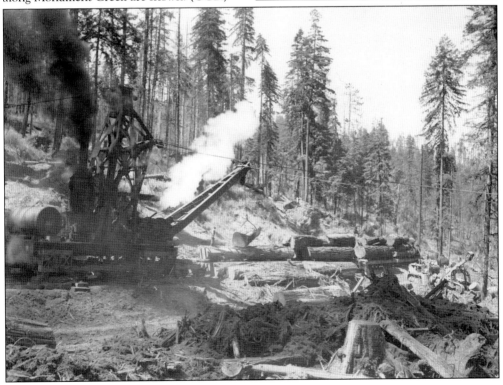

Sustainable harvesting was appealing to the lumber industry, since the Save the Redwoods League was successfully acquiring and preserving many redwood groves. Additionally, respected conservationist Gifford Pinchot advocated for a redwood national park. Further, a great deal of timberland was already logged off, meaning fewer trees to harvest. An unidentified man stands in a grove of 50-year-old trees belonging to TPL Co. (FDM.)

Furthermore, the public was becoming more vocal in protests about logging redwoods, a trend that was to continue throughout the 20th century. In 1937, the *Press-Democrat* reported plans to log near Founder's Grove resulted in "vigorous protest from throughout the redwood empire." The contested groves were protected, now forming part of Humboldt Redwoods State Park, and lumber companies became more conscious of what groves they logged. (FDM.)

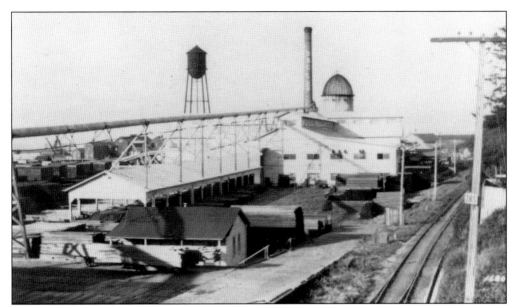

In 1938, Dolbeer and Carson (pictured here) celebrated its 75th year in business. At this time, Melendy notes, the company was "contributing a quarter of a million dollars annually to the Eureka payroll." Further south, TPL Co. extended its logging railroads south to Jordan Creek, thus providing enough logs to keep five headrigs in operation at the mill. (HCHS.)

In 1939, a tourist with the initials H.C.S., from Decatur, Illinois, wrote about his trip to Humboldt County in the *Decatur Daily Review*, describing the redwood lumber industry. H.C.S. was impressed with the redwoods, noting the trees can be "2000 years and more, old, 350 feet tall standing so close together one can see only a few feet." (Library of Congress.)

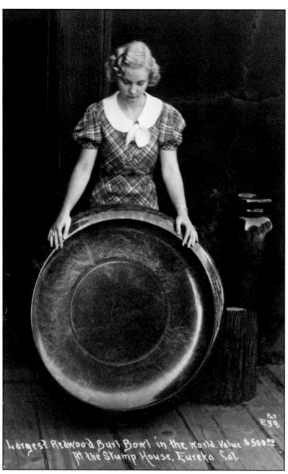

Largest Redwood Burl Bowl in the world. Value $500.00
At the Stump House, Eureka, Cal.

H.C.S. was also amazed by the "variety of uses made of redwood beside lumber. Here in Eureka a perfume is made and an Inhalatum for Hay Fever . . . the firm making these things also makes buttons, pitchers, vases, dolls, and so on mostly curiosities." This firm likely made many items from redwood burls. Burl wood creations found a ready market among travelers to the redwoods. (HSU.)

H.C.S. visited Scotia, finding "1000 men at work and 350 more back in the forests." W.C. Dorsey, company controller, explained the company's timber range was 20 miles long. Further, Dorsey felt "if you could come here in 500 years this mill would be running. We have timber for 200 years as we are now cutting and we are leaving the second growth standing. It will ensure a permanent supply." (FDM.)

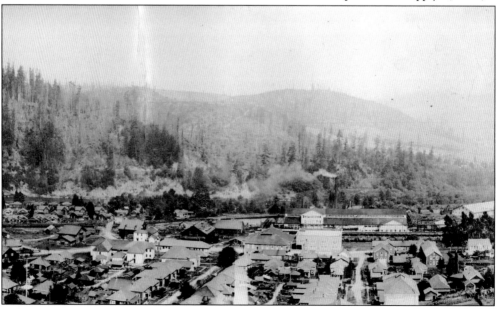

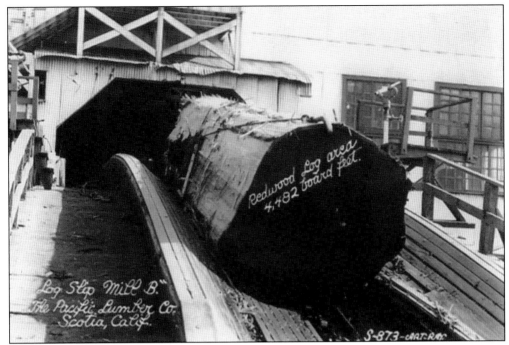

At the mill, H.C.S. described how "a big log, eight feet thick, 30 feet long, floating in a pond suddenly starts up a steel trough. Inside the mill, a man stands before a stand of small levers. A slight move of his hand and the log rolls off a platform, huge arms reach up, turn it, set it on a carriage, and clamps come down tight." Once in the mill, H.C.S. continued, "The carriage springs forward to a bandsaw that swiftly slices off the sides, then turns the logs into inch planks, 30 to 40 inches wide, all in about a minute and a half. The saws are bands, a foot wide, and in total length about 60 feet, moving so fast the inch and a half teeth are not visible." (Above, HCHS; below, HRIA.)

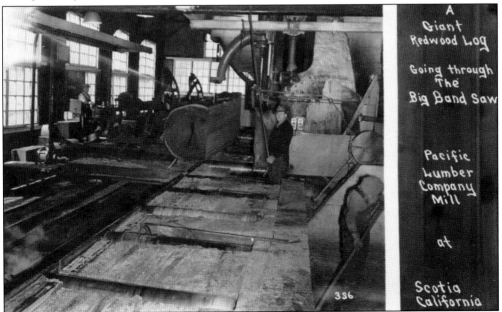

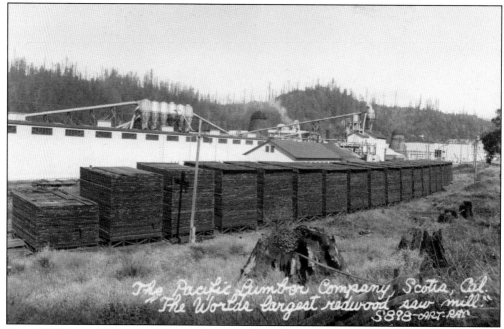

The Pacific Lumber Company, Scotia, Cal. "The Worlds largest redwood saw mill." 5898-ART-EM

Next, H.C.S. noted, "Planks move to other saws where they are split into smaller widths and lengths and out to be piled in a yard a mile along the highway. There are 85 million feet of lumber in the yards and houses of the company." He observed the "mill, in eight hours cuts 500,000 feet of lumber." The mill was becoming a tourist attraction and developed a walking tour guidebook. (HRIA.)

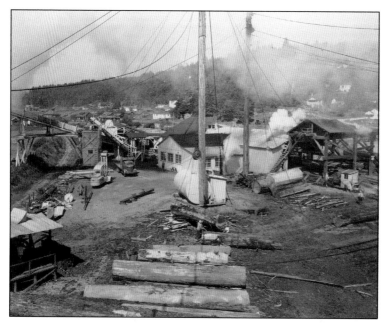

A sign of the Depression's end was the incorporation of a new mill, Arcata Redwood Company, in 1939. General manager Howard Libbey had previously worked for the Hobbs, Wall & Company mill in Del Norte County. The Arcata Redwood mill could produce 20,000 board feet a day and was set up to ship its product either by truck or by rail, making it a truly "modern" mill. (HCHS.)

The Elk River Mill & Lumber Company at Falk closed in 1939, selling its lands to Hammond the following year. In a departure from previous years, the timber was logged by contract loggers. William Hess was the contractor in this 1942 image. Contract loggers were independent from the mill, selling logs harvested to local mills, and were paid for the scaled amount of board feet in the truckload of logs. (UCB.)

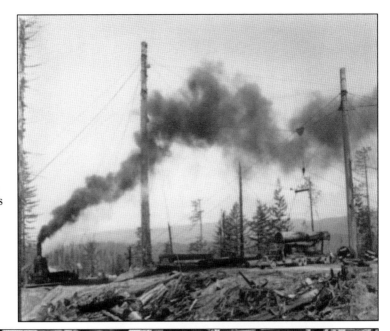

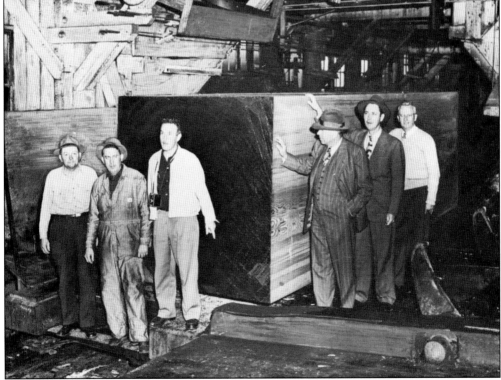

Also in 1939, the founder of the Holmes-Eureka Company, J.H. Holmes, died at his home in Berkeley. His estate was valued at $49,550. At the time of Holmes's death, the company had transitioned away from railroads and used logging trucks exclusively. The mill operated for another 19 years under the guidance of Holmes's son Fred Holmes. Pictured are unidentified Holmes-Eureka employees. (HCHS.)

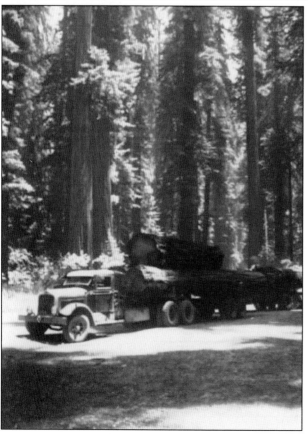

In 1940, TPL Co. sold 400 acres to the California state park system for $217,000, helping the company purchase 22,000 acres in the Yager and Lawrence Creeks drainages. According to the *Timberman*, TPL Co. estimated the virgin timber "would be sufficient for twenty years of logging." Indeed, some 40 years later, the company was still logging these lands. The image above shows two RD-8 Caterpillars skidding one log across Yager Creek. By 1941, the company was also regularly cutting second-growth trees. TPL Co.'s mill at Scotia began being referred to as the "Largest Redwood Lumber Mill in the World." Melendy observed, "The two sawmills at Scotia required 400,000 [board] feet a day to operate at normal capacity in 1940." At left is a loaded logging truck pulling onto Highway 101 in June 1941 at Jordan Creek. (Both, UCB.)

Until the 1940s, Douglas fir had typically been logged only for specific purposes, including shipbuilding, to make marine pilings, and to soften the landing of falling redwoods. (To prevent fracturing, smaller fir trees with their limbs on were used, creating a "bed" for redwoods to land on.) Douglas fir was logged extensively in the remainder of the 20th century, for both lumber and plywood. This 1950s image shows Douglas fir being logged with a chain saw. (FDM.)

The interior of the Carson mill is shown here. John M. Carson, son of William Carson and president of Dolbeer and Carson Lumber Company, died in August 1941. In 1950, TPL Co. purchased "the assets of the Dolbeer and Carson Company for $4,500,000. With this new purchase The Pacific Lumber Company . . . increased its area to 131,000 acres," noted the *Humboldt Standard* in 1969. (Clarke.)

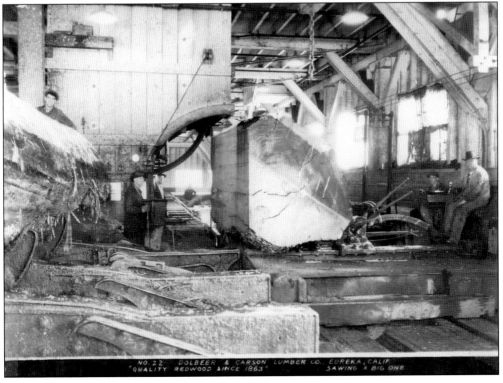

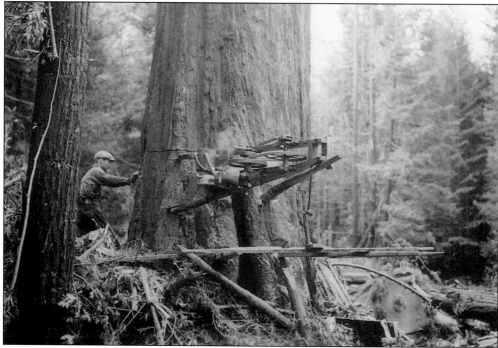

When the United States entered World War II in 1941, young men were called up, creating a labor shortage. Taking their places were older men and women, similar to World War I. Logging was vital to the war effort; in 1943, Professor Fritz informed the *Press Democrat* that "in excess of 500,000,000 board feet of redwood is being cut annually." The paper noted, "Practically all the redwood now is going for cantonments for war housing, for water tanks, water supply lines and industrial buildings. The weather and decay resistant bark . . . is being used as insulation." Additionally, TPL Co. experimented with redwood bark, combining bark fibers with wool, creating a cloth that saved from 15 to 60 percent of the wool normally used. This was significant since wool was in demand for Army uniforms. The redwood-wool blend fabric was also used to make hats. (Above, FDM; below, HRIA.)

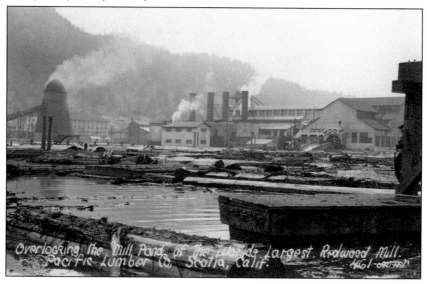

Overlooking the Mill Pond of the World's Largest Redwood Mill. Pacific Lumber Co, Scotia, Calif.

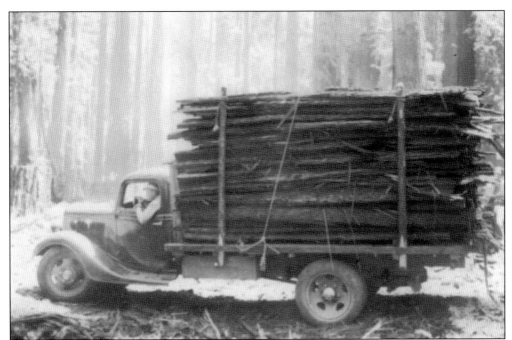

In 1944, TPL Co. blended shredded bark with cotton, creating a fabric used in "mattresses, pillows, comforters, and blankets," noted the *Press Democrat*. The Army put "the mattresses through field tests at Camp Lee, Va.," reporting "they gave satisfactory service." The paper observed that "redwood fiber is resilient and resists moisture, so it gives a springy quality to cotton blended textiles." (UCB.)

Darrel Bean described logging in the 1940s for the *Humboldt Historian*. Rejected from enlistment in the Navy for health reasons, Bean instead worked on the "rig up crew" for Hammond Lumber Company from 1943 to 1945. Bean observed he supported the war effort by buying war bonds every payday. A Hammond rig up crew of the era is pictured. (HSU.)

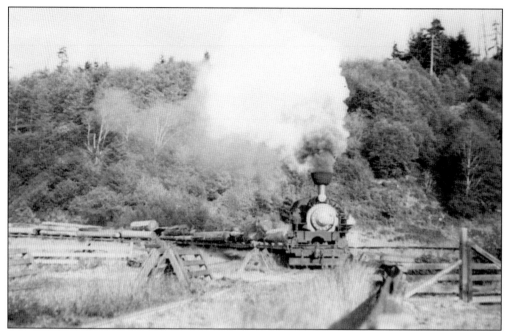

Bean commuted on Hammond's logging railroad from Luffenholtz to woods operations "in the hills behind Big Lagoon," where his duties included setting up landing sites with a spar tree. Bean explained, "Logs were yarded or drug in, using a steam donkey engine for power. The main line pulled the logs in and the haul back line pulled the rigging back out into the 'brush' for the choker setters to hook more logs on." The spar tree was supported with guy lines making it secure near the steam donkey. A high wire, referred to as the "sky line," connected the donkey and the spar tree. Another line, the "baloney," connected to a "tail tree" across the canyon. Suspended from the baloney were two 45-foot-long chokers that were hooked onto logs in the canyon, hauling to the landing. (Both, HSU.)

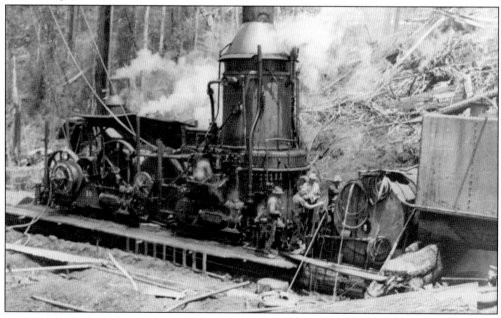

Bean describes obstacles he faced as a choker setter, his next job in the woods. Choker setters had to be "quick, agile, and sure footed because [they] had to run full speed over broken timber, limbs, rocks and logs. When the rigging began to descend . . . [they] would run and catch the chokers . . . before they touched the ground and were too heavy to handle. The trick was to catch your choker and run with it over your shoulder to the log pointed out by the hook-tender as the one to be sent into the landing. As soon as the two choker setters had their chokers wrapped around a log and fastened to the 'bell,' the hook tender would shout the signal 'Hup ho!' and you had better be getting out of the way fast." Unidentified choker setters are shown here. (Above, UCB; right, HSU.)

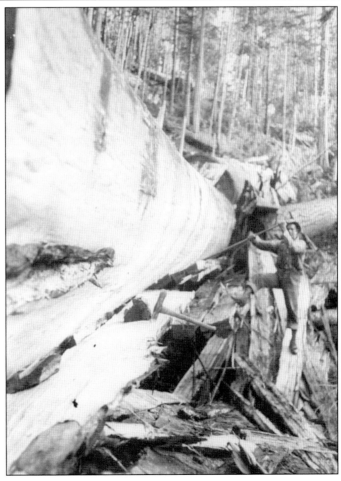

By 1945, mills that had closed due to the Depression reopened, such as the Korbel Mill, employing 200, while those that had restricted hours were now working full shifts, often two a day. Melendy notes, "The redwood mills prospered greatly during the war as the armed forces brought needs for all kinds of lumber without much regard to cost or quality." Shown are Dolbeer and Carson employees loading a railroad car in the mid-1940s. (HCHS.)

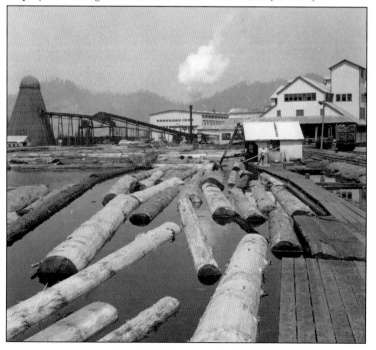

By the end of World War II, Melendy notes that mills that survived the Great Depression "found their books showing profits." In 1945, "various mills of the county were turning out lumber at top capacity." This ranged from 36,000 feet daily by Arcata Redwood Company to 600,000 feet daily at TPL Co.'s mills (shown). This marked the end of one era of the lumber industry and the start of the next. (HRIA.)

Four

FACES OF THE LUMBER INDUSTRY

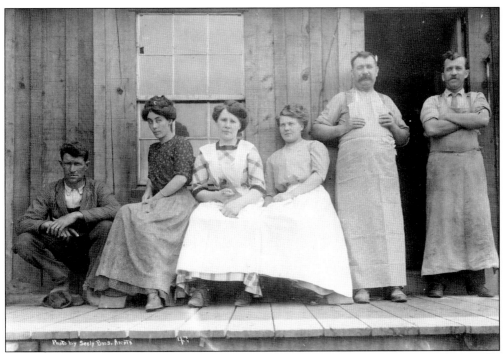

Workers like this Arcata-area cookhouse crew were integral to Humboldt's lumber industry. The apron-clad cooks standing at right may be a father-and-son team, such as Joe Filgas and his son John, cooks for the Northern Redwood Company in Korbel in the 1910s and 1920s. Rose Bussiere worked in the Korbel cookhouse in those years, and she recalled that her workday began at 4:00 a.m. and often continued until 10:00 at night. (HCHS.)

Another cookhouse crew clowned for the camera somewhere in northern Humboldt. Visible behind them are signs for the Arcata & Mad River Railroad and Eureka's Union Labor Hospital. When Rose Bussiere was a Korbel waitress, pay was $45 a month plus room and board. Life was not all work; Bussiere recalled the fun of the summertime Saturday night dances at Korbel's Camp Bauer, lasting from 9:00 p.m. to 3:00 a.m. (HSU.)

Amanda Smeds, left, is pictured in Eureka with niece Mildred and sister Augusta Malm. Smeds emigrated from Finland with brother Axel and their widowed father in 1906. The next year, they came to Eureka, where siblings Augusta and Vilhelm (Billy) had already settled. Smeds worked at Hammond's Samoa cookhouse in 1907. Hammond's waitresses at the time received $30 a month and did not earn a day off until they were employed for five weeks. (Dave Smeds.)

Amanda Smeds soon left the Samoa cookhouse, helping her sister and brother-in-law run their Eureka boardinghouse. While still at the cookhouse, she met her brother Billy's friend and fellow logger Charlie Strom, another immigrant from Finland. Strom is standing at left in this photograph of Newburg woods crew members around 1912. Smeds and Strom married in 1915. (Dave Smeds.)

Shown is the Eureka office of machinery manufacturers Cheney, Kelly, and Reid. At left is believed to be bookkeeper Frank Reid, who emigrated with his family from Canada in 1877 at age two and grew up in Eureka. He and Harry Kelly worked as managers at the Buhne store, and the two friends joined forces with Arthur Cheney to open their own machinery retail business around 1905. (HCHS.)

This stump stable in Scotia stood where TPL Co.'s machine shop was later located. From left to right are Fred Philipp, Mike Brown, Hugo Philipp, and Ted Giffins, with dog Marko. The Philipp brothers came from Kiel, Schleswig-Holstein, Germany; Fred's full name being Johan Frederick Philipp. Fred worked for TPL Co. 43 years. He arrived in California in 1903, working at a Mendocino County ranch and then hiking with a friend to Scotia to seek work. (FDM.)

Some men stayed with one company; others moved from mill to mill. Like Fred Philipp before him, 19-year-old Fred Pritchard left Mendocino in 1909, walking to Humboldt County. His first stop in Eureka was the first saloon he found. He worked several months at the Hammond mill yard and then moved on, heading to Oregon. Pritchard is shown at right with brother James (left) and friend Jay Nelson. (FDM.)

John Maples is shown at left in this photograph of a saw-filers' shed. Maples is listed in the 1909 Humboldt directory as a woodsman living in Scotia. According to the 1910 census, he and his wife, Myrtle, lived in Hydesville, with John listed as a 31-year-old California-born "rigging puller—logging woods." John and Myrtle divorced in 1918, and in the 1920 census, he appears as a woodsman in Eureka. He died in 1929 at age 51. (HCHS.)

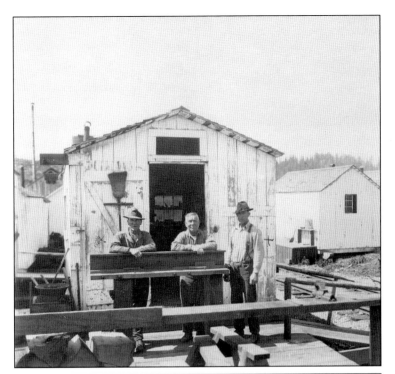

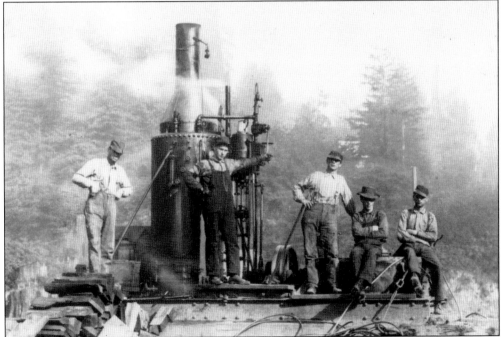

Shown in this photograph of an Elk River Lumber Company donkey crew are Albert McManus (second from left) and his uncle Elijah Barnes (third from left). Both Barnes and McManus worked as logging railroad engineers. McManus's father, James, also worked in the lumber industry, listed as a laborer in the woods in the 1900 census and as a lumber millpond man at age 66 in 1940. (HCHS.)

A note on this snapshot reads, "Jack Trego bark peeler near Camp 20." In the Humboldt directory of 1928, when Trego was 20 years old, he and his father, Walter, are listed at Hammond's Camp 20 near Trinidad, Walter as brakeman and Jack as carpenter's helper. Both were Camp 20 brakemen in 1930. By 1938, Jack was a logging railroad conductor in Samoa. (HCHS.)

Frank Barnum, left, had a varied Eureka-area career. Unlike many lumber workers, he did not follow in his father's footsteps; his father was a saloon keeper. Census records show Barnum as a policeman in 1900, an oil well superintendent in 1910, a lumber mill tallyman in 1920, and a mill watchman in 1940. In the 1948 business directory, when he was around 80 years old, he is listed as a cabinetmaker. (HCHS.)

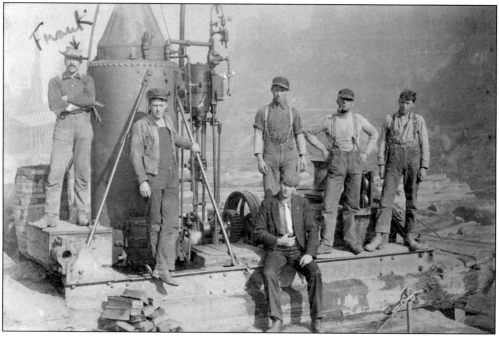

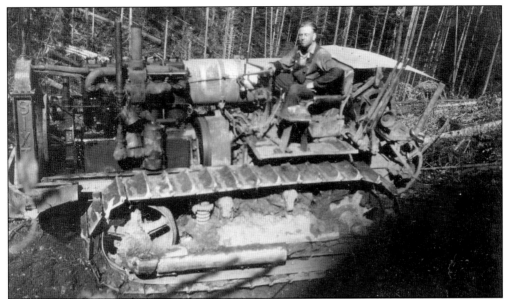

Richard "Dick" Norberry, born in 1904, was another Hammond employee. In the 1920 census, his father was listed as a planing mill foreman and his three elder brothers as a locomotive fireman, a lumber mill oiler, and a lumber grader. In 1926, Dick Norberry was an engineer at Camp 40; in 1937, a machine operator in Samoa; and the 1940 census lists him as "tractor operator, lumbering." (HCHS.)

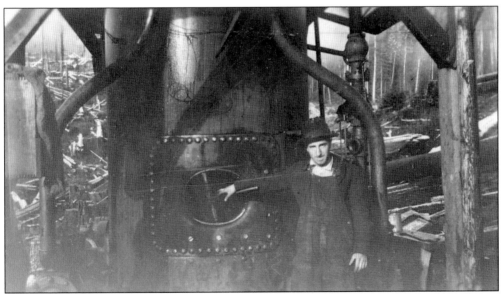

Olivo de Zordo, the son of Italian immigrants, was born in 1897 in San Francisco. His father, Vincenzo, known as Vincent in the United States, was a shingle bolt maker in 1900 and a saw filer in 1910. Olivo worked in the Arcata Barrel Company factory when he registered for the draft in 1918. He served as a private in World War I. After returning from the service, Olivo became a boilermaker for the Eureka Boiler Works. (HCHS.)

Not every child of the lumber industry followed in their parents' footsteps. Grace Rushing grew up in Falk, and her father and two of her brothers worked for the Elk River Lumber Company. In the 1914 voter registration records, she is a businesswoman living in Falk, registered as a Progressive. Shortly after, she moved to San Francisco, trained her voice, and became a professional opera singer, performing in San Francisco and New York as Madame Henkel. (HCHS.)

A note on this snapshot states that Wilbur Kammerzell, a 1929 Eureka High graduate, "worked his entire life in Redwood Burl." The 1930 Humboldt directory shows Kammerzell's mother, Pauline, as a redwood novelties saleslady for William Waers and Wilbur as Waers's wood turner. Apart from three years in the Army during World War II, Wilbur indeed worked as a burl carver throughout his career. He is listed as lathe operator for Rex's Redwood Shop in 1971. (HCHS.)

William Waers's burhl factory crew in 1933 is, from left to right, (standing) Carrie Waers, Lena Del Grande, Wilbur Kammerzell, Bill Waers, Warren Fridley, Harry Somerhouse, and an unidentified child; (kneeling) Vivian ? and Gertrude Kinney. Waers advertised "Novelties and souvenirs . . . from California's most rare wood," including "growing or ornamental burhls, [and] burhl lamp shades." Until the mid-20th century, "burl" and "burhl" were used interchangeably. (HCHS.)

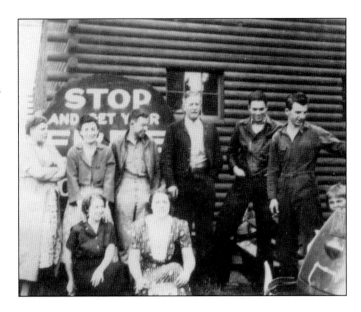

Doug Rex is shown in the back center with his burl shop employees in 1941. Wilbur Kammerzell is just visible at left in the fourth row. Rex opened his first redwood novelties shop around 1933. He retired in 1979, and Rex's Redwood Gifts continued under new ownership. The business was advertised as Eureka's "oldest manufacturers of the finest in redwood burl gifts." In the 1940s, its products included redwood perfume. (HCHS.)

Among employees at Northern Redwood Company's Korbel store around 1927 is Brunetto Papini, third from left. Papini was born in Brazil of Italian parentage, and his family came to Humboldt in 1901. His father, Antonio, worked for Northern Redwood for 30 years. Brunetto and his brothers became owners of Papini Bros. grocery store in Arcata. (HCHS.)

These California Barrel Company employees in the late 1930s are, from left to right, Ellen Larsen, Margaret Wymore, Frank Lane, Esther Wymore, and Josephine Gallacci. Esther, Ellen, and Josephine were all Arcata High graduates, Esther in the class of 1933 and Ellen and Josephine in the class of 1934. Josephine's motto in the 1934 yearbook was "Lighthearted, with never a care is she," and Ellen's was "Why worry? We only live once." (HCHS.)

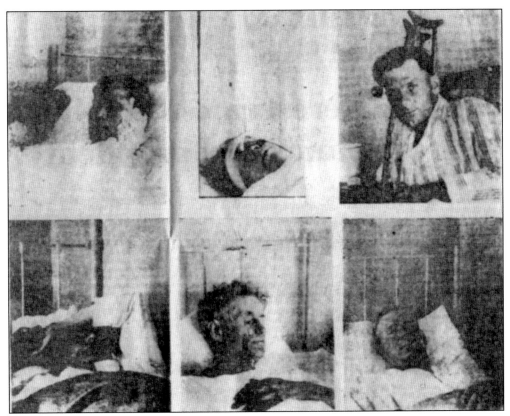

Protestors injured in the June 21, 1935, strike included, from left to right, (top row) Barry Phillips (shot in the face), Paul Lampella (shot through the eye), and union organizer Eugene Miller (shot in the leg); (bottom row) V. Johnson, W. Adams, and Ole Nelson, all of whom were shot in their legs. Twenty-one-year-old Lampella died on August 7, leaving his parents and a 10-year-old sister. (HCHS.)

Lampella was born in California to parents who emigrated from Finland. The other two fatalities of the strike, Gustav Wilhelm Kaarte and Harold Edlund, shared Lampella's Finnish heritage. Kaarte, described as a "woods cook" in newspaper coverage, came to America in 1887 at age 13. Edlund, who arrived in the United States in 1923 at age 25, was shot while attempting to aid the injured Paul Lampella. (FDM.)

MASS FUNERAL PLANNED FOR RIOT VICTIM

The third mass labor funeral since June 21 will be held at 1:30 p. m. Saturday for Paul Lampella, 21, who died at the county hospital last night, 47 days after he was shot n the disturbance at the Holmes Eureka mill entrance.

With a bullet at the edge of his brain, Lampella had been only semi-conscious for weeks. From x-rays taken of the skull, it was determined that an operation to remove the bullet would have likewise proved fatal and no effort was made to do so. He was shot through the left eye.

Funeral services will be in charge of the executive committee of the Lumber and Sawmill Workers Union, of which Lampella was a member. J. B. Williford, Albert Lima, Everett St. Peter, Charles Peterson, Eugene Miller, O. H. Barnes, Elmer Fox, Maynard Stegeman, Arthur Lofgren and John George are members of that committee, which met this noon to make preliminary plans.

In 1938, Holmes-Eureka superintendent George Cartwright designed a new mill gate. Here, he poses by a scale model with Eureka High School student Marian Dalton, whose father, Walter, became Holmes-Eureka's second president in 1939. Cartwright had designed Holmes-Eureka's mill in 1903. In another local claim to fame, his daughter Elta Cartwright was a Eureka High track star and competed in the 1928 Olympics. (HCHS.)

Fred V. Holmes graduated from Eureka High (having played on the EHS football team) in 1910, the same year that his father, J.H. Holmes, moved Holmes-Eureka's company offices to San Francisco and relocated his family there. Fred attended the University of California and became the Berkeley-based sales manager for Holmes-Eureka. In 1942, he became the company's third president. (HCHS.)

This portrait of Bert King was distributed by the Caterpillar Tractor Company, advertising that Korbel's Northern Redwood Lumber Company used Caterpillar tractors in building its logging roads. King was Northern Redwood's superintendent in the mid-1940s. His father was a boardinghouse landlord in Siskiyou County, where King was born in 1908. By 1935, King was working for TPL Co. He is listed in Scotia as a logging foreman in the 1940 census. (HCHS.)

This Hammond Lumber Company employee in the 1940s may be enjoying a meal prepared by Czech-Moravian–born chef Tony Gabriel, who worked for Hammond and its successor company, Georgia Pacific, from 1920 to 1964. On Gabriel's death in 1969, an obituary described him as "the Paul Bunyan of the cookhouse." A newspaper article profiling Gabriel and his wife, Frances, was headlined "60 Tons of Pancakes," though Gabriel estimated he had served far more pancakes than that. (HCHS.)

Ray Shull, of Hammond Lumber, described by the *Humboldt Standard* as a "giant young Humboldter," won the April 1937 log-bucking competition in Scotia by sawing through a 34-inch redwood log in three minutes, 38 seconds. On May 28, 1937, the six-foot, five-inch Shull competed in San Francisco against champion sawyers of Idaho and Washington during the Golden Gate Bridge's opening ceremonies. Winning that event was Paul Searles of Longview, Washington. (HCHS.)

Holmes-Eureka's tug-of-war team became champions on July 4, 1941, triumphing over fellow finalists, the Hammond team, at Eureka High's Albee Stadium. The program also featured the Southern Pacific band and a Shirley Temple impersonator. The tug-of-war competition was part of a five-day-long Fourth of July celebration. Also fielding teams were Dolbeer and Carson, Crannell, TPL Co., Arrow Mills, Lundblade, and the Garberville Tie-Makers. (HCHS.)

ABOUT THE
FORTUNA DEPOT MUSEUM

In October 1974, Fortuna's 85-year-old train station moved across town to a new home in Rohner Park. Built by Carson and Vance's Eel River & Eureka Railroad and later a stop on the Northwestern Pacific (NWP) route from San Francisco to Humboldt, the depot was scheduled to be demolished by the NWP. Fortuna citizens convinced the city council to purchase the building and refurbish it as a local history museum. With its roof removed in order to fit under the town's power lines, the depot was raised from its foundations and loaded on a flatbed trailer. Through the work of city staff, local businesses, and many volunteers, Fortuna's venerable train station made its way down Main Street.

There followed a year and a half of renovations and assembling a museum collection through donations by area residents. The Fortuna Depot Museum had its grand opening on July 4, 1976, as Fortuna's bicentennial city project celebrating the nation's 200th birthday.

The train station was a center of community life, and the depot museum holds a special place in the hearts of Fortuna's people. Its mission is to preserve, share, and interpret the history of Fortuna and the Eel River Valley. The museum's reference room is a resource for historical and genealogical research, and its photograph collection has thus far formed the basis of four Arcadia publications. A highlight of the museum collection is Northwestern Pacific caboose No. 11, built in 1909 and donated to the museum in 2006. The greatest artifact in the collection is the depot building itself, showcasing Victorian construction and woodworking techniques and using the "red gold" of Humboldt's redwoods.

DISCOVER THOUSANDS OF LOCAL HISTORY BOOKS
FEATURING MILLIONS OF VINTAGE IMAGES

Arcadia Publishing, the leading local history publisher in the United States, is committed to making history accessible and meaningful through publishing books that celebrate and preserve the heritage of America's people and places.

Find more books like this at
www.arcadiapublishing.com

Search for your hometown history, your old stomping grounds, and even your favorite sports team.

Consistent with our mission to preserve history on a local level, this book was printed in South Carolina on American-made paper and manufactured entirely in the United States. Products carrying the accredited Forest Stewardship Council (FSC) label are printed on 100 percent FSC-certified paper.

MADE IN THE

USA